# Mexican Modern

## MASTERS OF THE 20TH CENTURY

ESSAYS BY DAVID CRAVEN
AND LUIS-MARTÍN LOZANO

MUSEUM OF NEW MEXICO PRESS

SANTA FE

# CONTENTS

**7**    FOREWORD
        Governor Bill Richardson

**9**    PREFACE
        Sari Bermúdez

**10**   SPONSOR'S STATEMENT
        Saúl Juárez Vega

**11**   ACKNOWLEDGMENTS

**15**   MEXICAN MODERNISM: 1920–1950
        Luis-Martín Lozano

**25**   THE MULTIPLE IDENTITIES OF MODERNISMS FROM MEXICO
        IN THE EARLY TWENTIETH CENTURY
        David Craven

**45**   MEXICAN MODERN: MASTERS OF THE 20TH CENTURY

## FOREWORD

BILL RICHARDSON
GOVERNOR OF NEW MEXICO

I am very pleased to have New Mexico participate in this monumental exhibition of works of art by the great Mexican masters of the postrevolutionary era. *Mexican Modern: Masters of the 20th Century* is a partnership between our Department of Cultural Affairs and Mexico's CONACULTA that demonstrates the appreciation we have for the artistic legacy of Mexico. Growing up in Mexico City, it was part of everyday life to hear the names of Diego Rivera, José Clemente Orozco, and David Alfaro Siqueiros. These are some of the artists represented in this unprecedented exhibition of Mexican art at the Museum of Fine Arts in Santa Fe.

The period from the 1920s to the 1950s was truly a golden age of the arts in Mexico. Artists working in this period established an art that was identifiably Mexican. Coming from centuries of perhaps the most significant legacy of indigenous art in the world, these now internationally recognized artists contributed greatly to the enrichment of this global artistic legacy.

The exhibition strengthens and asserts the deep historical ties that exist between Mexico and New Mexico. Not only do we share a name with our neighbor to the south, we also share cultural roots and many traditions that are part of our quality of life.

It is interesting to note that our Museum of Fine Arts was established in 1917, the same year that Mexico forged its constitution.

We welcome this prestigious collection from the Museo de Arte Moderno de México to New Mexico and we hope to continue our tradition of cultural and artistic exchanges with our friends in Mexico.

## PREFACE

SARI BERMÚDEZ

CONSEJO NACIONAL PARA LA CULTURA Y LAS ARTES

The international recognition Mexico's modern art enjoys has led once again to the presentation of the work of our great masters in a new exhibition. At this time the Museum of Fine Arts in Santa Fe has a loan exhibition of more than fifty representative works of twentieth-century Mexican art. This selection, provided from both private collections and that of the Instituto Nacional de Bellas Artes de México, represents Mexican modernism through pieces that, while comprising a variety of styles, establish an intense dialogue that our complex aesthetic identity raised.

*Mexican Modern: Masters of the 20th Century*, which the Consejo Nacional para la Cultura y las Artes has arranged through the Instituto Nacional de Bellas Artes and the Museo de Arte Moderno de México, gives due place in the history of art not only to the essential works of Diego Rivera, José Clemente Orozco, and David Alfaro Siqueiros, but also to the generation of Los Contemporáneos, represented in prominent works of Juan Soriano and Rufino Tamayo, and selected photographs by Manuel Álvarez Bravo, Edward Weston, and Tina Modotti.

One of our most important duties is to make the significance of Mexican art known throughout the world. Through the transcendental works of our country's artistic creation, we must show the public outside Mexico how to appreciate the avant-garde ideas that lead to an understanding of the rich artistic process of Mexico, which sought its identity throughout the first half of the twentieth century.

## SPONSOR'S STATEMENT

SAÚL JUÁREZ VEGA
*General Director, INBA*

The twentieth century was one of the most intense periods of aesthetic production in Mexico. In historical and political terms, what began as a revolutionary era aiming to securely establish a state totally different from the one that had ruled during the nineteenth century was reflected in the arts.

The birth of the Mexican school of painting, which was shaped by Rivera, Orozco, and Siqueiros, the three great muralists who were always intensely interested in giving the art of Mexico both identity and color, led to the many artistic searches that began midcentury and lasted over successive decades with important currents like the Ruptura. The result was a whole range of figures, styles, and artistic restlessness that appeared in Mexico's fine arts.

Ever since its foundation, the Museo de Arte Moderno has devoted itself to presenting this movement, gathering Mexico's tremendous cultural wealth and organizing what is currently known about the evolution of our fine arts, bringing the public closer to the many ways they are expressed. At the same time, the museum has dedicated its efforts to building bridges to other countries and seeking a permanent dialogue with related institutions. Such is the case with the *Mexican Modern: Masters of the 20th Century,* an exhibition on loan to the galleries of the Museum of Fine Arts in Santa Fe.

We have sought to make known, through the selection made by the knowledgeable staff of the Museo de Arte Moderno, just how vast the Mexican artistic universe is and bring it to a public with different points of view. We hope to offer a window on the many works, represented by different artists and disciplines, ushered in with the century. The scope of the exhibition ranges from the easel work of the great muralists and artists like Rufino Tamayo, Fermín Revueltas, Juan Soriano, Olga Costa, María Izquierdo, and Carlos Mérida, among many others, to the photographic explorations of Edward Weston, Tina Modotti, and Manuel Álvarez Bravo. It will no doubt serve as a valuable map for getting to know the routes modern Mexican art has traveled. For us, it is an invaluable opportunity to bring to the public an artistic patrimony that continues to offer an infinite number of interpretations and that today many Mexican artists take as their frame of reference and point of departure.

## ACKNOWLEDGMENTS

LUIS-MARTÍN LOZANO

The exhibition *Mexican Modern: Masters of the 20th Century* is a direct result of the close relationship between the authorities of the state of New Mexico, particularly Stuart Ashman, and the president of the Consejo Nacional para la Cultura y las Artes of Mexico, Mrs. Sari Bermúdez, who decided to join forces to direct this project. The enthusiasm and dedicated interest of Marsha Bol, director of the Museum of Fine Arts, has allowed this exhibition to find a safe haven. We are in debt to the generous collectors in Mexico: Lance Aaron and family, Agustín and Judith Alanis, Gene Cady Gerzso and Michael Gerzso, Héctor Fanghanel Hernández, Olinca Fernández Ledesma Villaseñor, Carlos Fournier, the Gutiérrez Saldivar family, Vicky and Marchos Micha, Mariana Morillo Safa, Eugenia Rendón de Olazábal, and the Revueltas family. My deepest gratitude goes to them for the opportunity to present several of these pieces of Mexican art in the United States for the first time.

I also wish to thank the Mexican institutions collaborating on this project: José Ortiz Izquierdo, María del Refugio Cárdenas, Alberto Sarmiento, and Cándida Fernández Calderón of the Banco Nacional de México and Fomento Cultural Banamex, for their decisive support on behalf of making Mexican art internationally known; and José Ramón San Cristóbal Larrea and Ángeles Sobrino of the Ministry of Finance and State Credit, who have so sensitively collaborated on everything that may result in placing a higher value on art in Mexico; and my colleagues, the directors of the Museo de la Ciudad de Aguascalientes and Delia Sandoval; Jorge Labarthe, director general of the Instituto Estatal de Cultura de Guanajuato; Federico Ramos and Marco Antonio Castro, directors of the Museo Casa Diego Rivera and the Museo de Arte Olga Costa–José Chávez Morado in Guanajuato; Roxana Velásquez and Margarita Arnal of the Museo Nacional de Arte del Instituto Nacional de Bellas Artes (INBA); Carlos Ashida and Sylvia Navarrete, director and assistant director of the Museo de Arte Álvar and Carmen T. Carrillo Gil of the INBA; Agustín Gasca Pliego, general director of the Instituto Mexiquense de Cultura; and the Museo de Arte Moderno del Estado de México. In the Instituto Nacional de Bellas Artes, I must emphasize the decisive support of Saúl Juárez, general director, and Daniel

Leyva, assistant general director for fine arts; Walter Boelsterly, former director of the Centro Nacional de Conservación del INBA, and Gabriela Martínez, head of the registry of works; Javier Oropeza, director of legal matters for INBA; and Patricia Pineda, director of INBA's publicity and public relations. I extend to all my appreciation for their invaluable support in reaching our goals. Finally, I would like to thank the entire team at the Museo de Arte Moderno de México, especially Natalia Pollak, head of the department of exhibitions, for their constant devotion and following up on all the details, which allowed us to put together this exhibition for the Santa Fe Museum of Fine Arts.

# Mexican Modern

MASTERS OF THE 20TH CENTURY

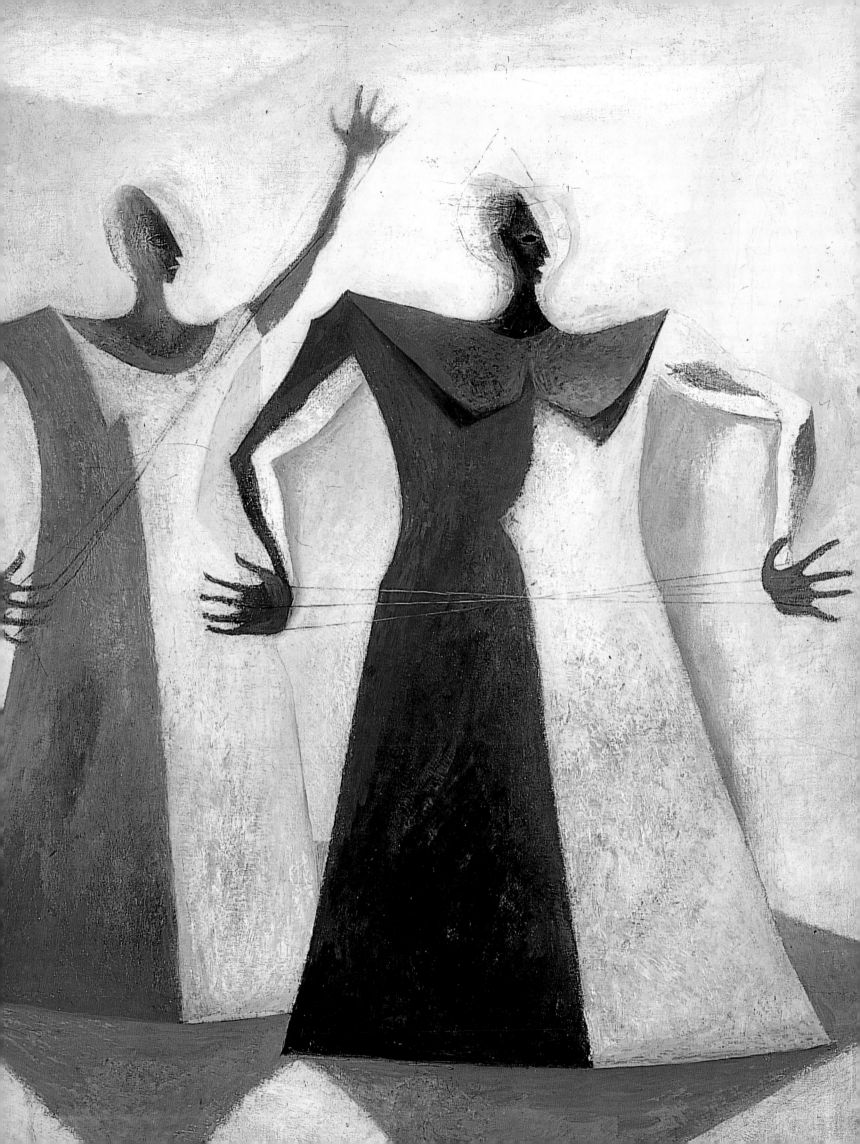

## MEXICAN MODERNISM: 1920–1950

LUIS-MARTÍN LOZANO
DIRECTOR, MUSEO DE ARTE MODERNO DE MÉXICO

**I**t is no easy task to attempt to show the development of the plastic arts in Mexico during the first half of the twentieth century in a single short-term exhibition. An undertaking presenting all points of view would have to include the work of several generations of painters, sculptors, photographers, engravers, architects, writers, and patrons of the arts, as well as the texts of art critics. They are all part of a complex historical and cultural process, which, given its richness and influence, has been correctly regarded as an authentic Mexican renaissance.

The term Mexican renaissance is an entirely fitting description of the prolific cultural activity that arose in Mexico in the first decades of the twentieth century. It establishes a proper comparison to the artistic blossoming that Italy experienced in the fifteenth century, particularly in the city of Florence. In both cases support for public art was expressed through the painting of murals and in architecture and sculpture. While it is true they are two different stylistic moments in the history of art, they have in common the fact that a strong state played a decisive role as a driving force in the arts and set itself up as a generous patron in support of artists.

For Mexico this increased support was the result, above all, of a particular event in our history. The country had survived a civil war lasting more than ten years. The Mexican Revolution of 1910 erupted with the century, and it must be remembered that it was the first great social movement of the twentieth century. By 1920 the Mexican nation was trying to overcome the ravages of the Revolution and longed to take a new path. To achieve this it would be necessary to actively enlist the artists and intellectuals of the time.

This is the background the selected works making up this exhibition of paintings and photographs emphasize. The curators seek to make known to a new public in the United States the tremendous aesthetic diversity through which Mexican artists attempted to express the cultural reality of their time. It clearly shows how they confronted the idea of being both Mexican and modern through different aesthetic strategies, simultaneously attempting to define their individual identities and claim their place in the international scene. In this way, although the exhibition does not include the murals

of Diego Rivera, José Clemente Orozco, or David Alfaro Siqueiros, to mention just three of the most famous Mexican Muralists, it clearly shows the many different positions the painters working in Mexico between 1920 and the early 1950s adopted.

In the face of generally held definitions and prejudgments about Mexican art, one of the primary objectives the cultural institutions of our country have is to demonstrate this principle of openness and plurality that the arts in Mexico lived. It is for this reason that we have assumed the task, with the unqualified support of the Consejo Nacional para la Cultura y las Artes and the Instituto Nacional de Bellas Artes of Mexico, of putting together a select group of paintings from the most significant public and private collections in Mexico. This effort has been further enhanced with loans from generous museums and collectors of Mexican art in the United States. Because of this, the selection includes not only masterpieces from the Museo de Arte Moderno de México, but also prominent works from the San Antonio Museum of Art and the Banco Nacional de México (Banamex), as well as from other institutions kind enough to facilitate the loan of works to the Santa Fe Museum of Fine Arts in New Mexico.

With regard to a Mexican renaissance, we have hoped to point out the visual richness the painters offer by including not only the essential works of Rivera, Orozco, and Siqueiros but also those of other, less well known artists such as Saturnino Herrán, Abraham Ángel, Fermín Revueltas, Gabriel Fernández Ledesma, Antonio Ruiz ( "El Corcito"), Carlos Orozco Romero, and Alfonso Michel, among others. Many of these artists have held shows in different cities and museums in the United States since the early 1920s, but over time their names and art have been forgotten.[1] Mexican women painters will also be magnificently represented, not only with a work by Frida Kahlo, but also those of María Izquierdo and Olga Costa. Complementing the oils is a small group of vintage photographs by Edward Weston, Tina Modotti, and Manuel Álvarez Bravo, who exemplify the avant-garde photography that appeared during the Mexican renaissance.

The preoccupation with achieving an autonomous cultural identity vis-à-vis Europe was not a source of unrest peculiar to Mexico but one the United States of America also shared. After attaining their respective independence from England and Spain, both countries directed themselves to defining their status as independent sovereign states. The arts would have to lend assistance, particularly in order to create a feeling of belonging to America and the visual symbols that represented the values and mores that would give us a distinctive character with regard to the rest of the world. Mexicans struggled for their political independence throughout the entire nineteenth century and had to overcome invasions by both France and the United States. In 1889 Mexico proudly presented itself to the World's Exposition in Paris with a highly esteemed contribution of works of art that showed the progressive development and political stability the country had finally

achieved. The United States did the same in 1893, when it organized the World's Columbian Exposition and showed the world both the degree of technological development it had reached four hundred years after Columbus's arrival on the American continent and the sophisticated level of design of its applied arts.[2]

For a long time excessive nationalistic sentiment in Mexico prevented recognition of the artistic merits of pre-Revolutionary Mexico. Through manipulation and sometimes out of great ignorance, there was an attempt to discredit the achievements of an entire generation of early twentieth-century Mexican artists. The painters and sculptors of the Porfiriato, that is, the final decade of the government of Pres. Porfirio Díaz (1830–1915), were pejoratively attacked for being *afrancesados*—affecting French styles—and serving the social and political class ruling the country. What is clear is that from the end of the nineteenth century and particularly into the early 1920s, artists such as Saturnino Herrán (1887–1918) and Alfredo Ramos Martínez (1871–1946) had already directed their talent to developing a style of painting that, while possessing great visual modernity, would also represent Mexicans' new cultural aspirations.[3] *La criolla del mango* (1916; plate 1) by Saturnino Herrán allows the public viewing the exhibition to appreciate some of the nationalistic preoccupations that appeared in painting during the Revolutionary years while demonstrating the faultless technical execution Herrán achieved before his death in 1918. For Mexicans, *La criolla* is a clear-cut example of *mestizaje*, the cultural mixing of Indian and Spaniard, but also of modernity and security.[4]

More eloquent, in terms of this exhibition's mandate, is the inclusion of *Maternidad* (1924; plate 2), a work by the painter Alfredo Ramos Martínez, since the artist, trained in Europe, moved to live in the United States by 1930 and realized several decorative murals in California.[5] Like Herrán, Ramos Martínez came out of the culture of the Porfiriato, and his work as director of the Escuela Nacional de Bellas Artes helped shape the archetypes of modern painting in Mexico even before the themes of the Mexican Muralists did.

As soon as the armed struggle came to an end, the postrevolutionary governments in Mexico devoted themselves to creating new institutions that would direct the social and political changes the country needed. After the reestablishment of education outside of church control, the Ministry of Public Education undertook an ambitious literacy campaign throughout Mexico. At the same time, the minister of education, José Vasconcelos, also understood the importance of culture serving as an essential bastion in defense of Mexican identity.[6] He prompted the establishment of programs that would stimulate artistic creativity among rural children and young people, as well as those from the working class, through a pedagogical project known as the Escuelas de Pintura al Aire Libre (EPAL; Outdoor Painting Schools). Although begun in 1913, these schools were actively

strengthened with the support they received under the presidency of Álvaro Obregón (1920–24). Together with the painting schools, Vasconcelos proposed that the Mexican state sponsor murals on public buildings. Under his direction, artists such as Diego Rivera, José Clemente Orozco, and David Alfaro Siqueiros became responsible for displaying a new vision of Mexico's future, now dynamic and changing with the conclusion of the Revolution. Mexican artists and intellectuals greatly benefited from the new state institutions' resolute support. In the following decades, programs in plastic arts, as well as in dance and theater, enjoyed protection and patronage from the state unknown before that time. By 1945, Mexico was moving toward industrial development while pursuing a vigorous, postrevolutionary cultural policy.

This exhibition and catalogue examine with great interest the years between 1920 and 1950. Evident at that time were the different ways in which Mexican painters tried to express their cultural identity and simultaneously define the right to create a deeply expressive modern art. After living outside the country for nearly fourteen years, famed painter Diego Rivera (1886–1957) joined the artistic milieu of the Mexican renaissance in 1921. Prominent as a cubist painter in Paris, Rivera rediscovered the beauty of his homeland and quickly came to understand—as perhaps no other painter of his generation—the importance of the aesthetic revolution developing in Mexico under the patronage of the state.[7] His first mural was a utopian vision of the development of the New Man, protected by the power of science and the arts. After traveling through the Isthmus of Tehuantepec and the Yucatán Peninsula, however, Diego Rivera fell in love with Mexico's landscape and peoples, whom he honored in his images in his murals and easel painting. *La bañista de Tehuantepac* (1923; plate 3) is one of the earliest works the muralist realized after arriving back in Mexico from Paris. One notices in it the sensual glance of the painter before the exoticism of the women stripped to the waist bathing in the warm, tropical water. Aside from their dark skin, they certainly call to mind Paul Gauguin's Polynesian paintings. In *La vendedora de pinole* (1936; plate 4) Rivera depicts a woman in the market at Juchitán selling sweet pinole from a basin richly adorned with flowers. Lost in her work, she is given the same monumental treatment Rivera brought to the epic scenes in his murals, particularly those done at the Ministry of Public Education around 1924.

Several Mexican painters of the 1920s and 1930s shared this vision, discovered through the eyes of modern artists, of a lost paradise. The selected works also include two by the painter Fermín Revueltas (1902–1935). One of the first to paint murals in Mexico, he died at thirty-two before reaching his full potential.[8] Like Rivera, Fermín Revueltas was profoundly attracted by the beauty of the Mexican landscape. Although he was unable to travel to Europe, his painting takes as its own a delicate modernity that at times approaches the painting of the Nabis in Paris at the end of the nineteenth century. What

interested the young painter was not *costumbrista* narration but the chromatic impression of the environment created by the effects of light and its reflection off water. Two paintings exemplify this: *Embarcadero de Ocotlán* (plate 8) and *La barranca de Oblatos* (1933; plate 7). A sublime vision of nature permeates both canvases, and the romantic relationship between man and his surroundings is alive. This quality also characterized the landscapes by Gerardo Murillo (1875–1964), known by the nickname Dr. ATL, whose grand scenes of the Mexican landscape from the 1940s are included in the exhibition.

Nevertheless, not all Mexican artists shared this idyllic vision. There were some who displayed a deep skepticism in their painting regarding the achievements of the Mexican Revolution and the benefits of the supposed social changes it had brought along with it. Muralists José Clemente Orozco (1883–1949) and David Alfaro Siqueiros (1896–1974) also created very different interpretations in their easel paintings. The solitude and restlessness the savagery of the Revolution brought with it or the unfulfilled promises of social justice made to the most vulnerable Mexicans were often present in these works. José Clemente Orozco always maintained a critical view as an artist, using his paintbrush to censure the excesses of nationalistic rhetoric in the speeches of the Mexican state. He frequently expressed in his works his preoccupation with the use of ideology to manipulate modern man's independent thought, be it religious dogma, as can be seen in the *Resurrección de Lázaro* (1943; plate 10), or in the face of the advance of authoritarianism, both in Mexico and in Europe or the United States.[9] Like José Clemente Orozco, David Alfaro Siqueiros and other painters as important as Jesús Guerrero Galván (1910–1973) and Guillermo Meza (1917–1997) also came to develop in some of their paintings a primarily existential preoccupation with man's condition vis-à-vis the power of the state or the negative effects of war, as well as the poverty in which thousands of Mexicans continued to exist.[10] Nevertheless, one of the great virtues of the modern painting of Mexico is that it did not limit itself to a universe of locally based ideas. Mexican painters were fully aware of the international context, both the realm of influence of the European avant-gardes and the historical events that were changing mankind's destiny. From Mexico, the artists also saw with horror what was happening in Europe and the devastation the Great Depression had caused in North American society during the difficult years of the 1930s.

On observing the works of Manuel Rodríguez Lozano (1897–1971) and Rufino Tamayo (1899–1991), it is clear that Mexican painters were familiar with artistic movements elsewhere in the world. Tamayo in particular was a very sophisticated painter. One can discern the resemblance even of his earliest works to paintings by Cézanne and Matisse, and later those by Picasso himself. Pablo Picasso's neoclassical monumentalism likewise nurtured some of Manuel Rodríguez Lozano's paintings, like the magnificent

piece *El pensador* (1935; plate 37), as well as other canvases by Julio Castellanos (1905–1947) and Alfonso Michel (1897–1957) that I have chosen for the exhibition. The body functions in all these works as a metaphor, sometimes for an excessive vision of existence, at others as a simple pretext for the practice of painting itself. What this underscores is that not all Mexican painting was interested in portraying political and social issues.

The intimacy of local expression will frequently also have points of contact with a culture of universal scope. That was probably how the influence of surrealism and the dreamy atmosphere of Italian abstraction became widely accepted in Mexico. For example, the paintings Carlos Mérida (1891–1984) realized halfway through the decade of the thirties are an international avant-garde opening, bringing to mind, through their organic abstract forms, Joan Miró and Jean Arp. Other works in the exhibition, like *Interior sin personajes* (1935; plate 48) by Gabriel Fernández Ledesma (1900–1983), have all the mystery of the abstract composition in the painting of Giorgio de Chirico. The same can be said of canvases like *Deseo* (1936; plate 45) and *Los hilos* (1939; plate 46), both by Carlos Orozco Romero (1898–1984). All these painters enjoyed enormous prestige in the 1930s and managed to exhibit their work in the Museum of Modern Art in New York in 1940.[11]

Irony and humor were resources that greatly helped the painters as well. Surrealists like André Breton, who visited Mexico in 1938, also extolled these qualities. Antonio Ruiz (1897–1964), known by his friends as El Corcito, painted small canvases that were often intimate visions of the everyday, satirizing political events of Mexico or the officialdom manning its institutions. In *Desfile cívico escolar* (1936; plate 20), for example, Indian children march in unison under their teacher's guidance, seeming to clothe themselves in equality by what they wear. The pupils pay homage to the heroes of their country in the background of a scene imbued with fantasy, when the subject at hand is really a veiled criticism of the Mexican political system. Another work included in the exhibition, *Líder orador* (1939; plate 21), proves to be even more eloquent; I consider it one of Antonio Ruiz's best compositions. It is the product of his caustic vision of the speeches politicians make, completely full of empty promises, to citizens who, more often than not, listen with no critical judgment of their own, as if they had heads as hollow as pumpkins.

Other paintings shown here, those of Julio Castellanos (1905–1947), Emilio Baz Viaud (1918–1991), and Juan Soriano (1920–2006), also glory in analyzing the hopes and amusements of daily life. Juan Soriano, who died just recently, was a painter who particularly rebelled in the presence of the social conventions of his time and the taste of the postrevolutionary Mexican bourgeoisie. The paintings of Soriano, who was a magnificent portraitist in his early years, foretold the stylistic changes in Mexican art subsequent to World War II. *Juego de niños* (1942; plate 51) should be seen as a painting depicting not

only a sincere scene of the filial love of children, but also as a metaphor for the excesses of free will and the anxieties creative freedom caused for an artist who, like Juan Soriano, rejected using art for political ends.

The Mexican Revolution allowed for upward social mobility, particularly for women, who saw themselves benefiting from a greater capacity to act in cultural life. The work of Frida Kahlo (1907–1954), very well known, is represented in the exhibition with one of her most beautiful still lifes. In *Los cocos* (1951; plate 29), the painter uses the organic forms of the fruit to reveal the key to her changing mental states. Also known as *Miradas*, Kahlo's small but powerful work shows a grieving coconut weeping, just as if it were a human face. Its distress parallels not only the pain Kahlo felt in her habitually ailing body, but also her existential anguish vis-à-vis life. This is candidly shown as slices of melon, whose flesh, exposed like a wound, is a metaphor for her own innermost feelings. Confined to a wheelchair, Kahlo wrote in her journal, "My solitude of years. My structure discordant, because inharmonious, unadjusted. I believe it is better to die and not run away. Let everything pass in an instant."[12] Her words make clear that for her, continuing to live was truly to suffer.

Although Frida Kahlo is the most well-known female Mexican painter worldwide, the truth is that during the 1940s it was the painter María Izquierdo (1906–1955) who was held in genuine high regard by art critics in Mexico. From the 1930s, writers, poets, and intellectuals had praised her work highly. Izquierdo's paintings had been shown in the United States since 1931, and her canvases were displayed in important museums, such as the Metropolitan Museum of Art in New York. Unlike Kahlo, María Izquierdo did not use painting as an autobiographical aid, but instead imbued her work with her profound belief in gender, where the feminine was elevated as an iconographic quality of incredible, sensitive features in the viewer's presence. Her handling of color established her expressive potential, for it had a chromatic harmony that unfolded in an overly intuitive way. Her work is authentically Mexican, both in its themes and colors and because it was strongly influenced by popular art. Izquierdo was a great admirer of nineteenth-century local and regional painting, and religious themes and ex-votos often inspired her canvases. The beautiful *Altar de Dolorosa* (1943; plate 34) is one such example, splashed with confetti and Mexican sweets and fruits.[13]

The exhibition also includes two works by the painter Olga Costa (1913–1993), a nationalized Mexican of Russian descent who shared this same feeling and profound appreciation for Mexican popular art. Born Olga Kostakowsky in Leipzig, she emigrated with her family in 1925, at the height of the Mexican renaissance. She knew Diego Rivera and studied painting in Mexico, later marrying the painter José Chávez Morado. Like María Izquierdo's works, Olga Costa's paintings draw their strength from everyday life

and her immediate surroundings, from provincial landscapes, from the colors of the flowers and fruits sold in the open-air markets. Izquierdo and Costa are perhaps the two female Mexican painters whom collectors value most highly, along with several others who had the opportunity to express their tremendous creativity in postrevolutionary Mexico.

The exhibition also includes a select group of photographs from the collection in the Museo de Arte Moderno de México. These are the images Edward Weston (1886–1958) and Tina Modotti (1896–1942) realized in the 1920s, as well as a selection of Manuel Álvarez Bravo's most representative photographs. Weston and Modotti arrived in Mexico in 1923, drawn, like many other artists and intellectuals from the United States and Europe, by the fascinating artistic climate favored in Mexico during the postrevolutionary period.[14] Weston came preceded by his reputaion as a renowned photographer, while Modotti arrived ready to begin a new stage in her life. Mexico's social and cultural reality had a decided influence on Weston's work and changed Tina Modotti's calling and beliefs forever, as she became a photographer in her own right. Weston went beyond the rationalistic purity of the avant-garde, allowing himself to be seduced by popular Mexican art forms, while Tina Modotti moved from her first compositions, like *Cañas de azúcar* (1929; plate 22), to a socially committed photography preoccupied with the human condition and sensitivity for the individual, as in *Niña tomando pecho* (1926, plate 23).

The work of both went on to influence Manuel Álvarez Bravo (1902–2002), who began his career as a photographer at that time. It was Modotti, above all, who unlocked for the Mexican an avant-garde photography deeply rooted in Mexico and its reality. He who was not a student surpassed the one who was not a teacher. Álvarez Bravo burst into the history of photography with a singular personality. He was an artist who could not be explained in any country other than Mexico, who was nurtured his whole life by its complex reality and culture. Álvarez Bravo not only learned how to discover the beauty hidden in everyday life, but also, as a master of the lens, successfully reached the highest degree of existential reflection that only a few pens of Latin American literature would equal. What I am thinking of here are the similarities of mind evident in the written works of Juan Rulfo and Manuel Álvarez Bravo's photographs.

It is our hope that this selection of works will be but a first approach to one of the most vigorous offerings of modern art presented in the cultural history of the twentieth century. It seems to me that despite the interest audiences in the United States have always shown in Mexican art, much yet remains to be revealed. I sincerely hope that the work of the painters assembled here will open the eyes of those visiting the Museum of Fine Arts in Santa Fe, encouraging them to continue exploring the fascinating artistic culture of modern Mexico.

## NOTES

1. For further information on some of these painters, I recommend reading MacKinley Helm's *Modern Mexican Painters* (New York: Dover, 1989).

2. See *Tiffany at the World's Columbian Exposition* (Palm Beach: Henry Morrison Flagler Museums, 2006).

3. For the work of this generation of Mexican artists, consult "Mexican Modern Art: Rendezvous with the Avant-Garde" in the exhibition catalogue by Luis-Martín Lozano et al., *Mexican Modern Art, 1900–1950* (Ottawa: National Gallery of Canada, 1999).

4. See Víctor Muñoz Herrán, *La pasión y el principio* (Mexico City: BITAL Grupo Financiero, 1994).

5. See the exhibition catalogue, *Alfredo Ramos Martínez (1871–1946), Una visión retrospectiva* (Mexico City: Museo Nacional de Bellas Artes, 1992).

6. On the minister of education's cultural work, consult Claudia Fell, *José Vasconcelos: Los años del águila (1902–1925)* (Mexico City: Universidad Nacional Autónoma de México, 1989).

7. See the exhibition catalogue *Diego Rivera: Art and Revolution* (Mexico City: Consejo Nacional para la Cultura y las Artes–Instituto Nacional de Bellas Artes, 1999).

8. See the exhibition catalogue from the Museo de Arte Moderno de México, *Fermín Revueltas, 1902–1935: Muestra antológica* (Mexico City: Instituto Nacional de Bellas Artes-La Sociedad Mexicana de Arte Moderno, A.C.) and Carla Zurián, *Fermín Revueltas, constructor de espacios* (Mexico City: Instituto de Bellas Artes–Editorial RM, 2002).

9. See *José Clemente Orozco in the United States, 1927–1934* (Hanover, NH: Hood Museum of Art, Dartmouth College, 2002).

10. Perhaps less well known today, the work of Guillermo Meza and Jesús Guerrero Galván was nevertheless much appreciated in the 1930s by Americans who were collecting Mexican art. It is no surprise that there may be paintings by both in the collections of some important museums in the United States.

11. See the exhibition catalogue by Luis-Martín Lozano, *Arte Moderno de México, 1940–1950* (Mexico City: Antiguo Colegio de San Ildefonso, 2000).

12. See *El diario de Frida Kahlo: Autorretrato íntimo* (Mexico City: La Vaca Independiente, 1995). Kahlo's journal is difficult to understand, but there is an English translation of a facsimile edition available.

13. See Luis-Martín Lozano, *María Izquierdo, una verdadera pasión por el color* (Mexico City: Consejo Nacional para la Cultura y las Artes, 2001).

14. See Sarah M. Lowe, *Tina Modotti and Edward Weston: The Mexican Years* (New York: Merrell Publishers, 2004).

# THE MULTIPLE IDENTITIES OF MODERNISMS FROM MEXICO IN THE EARLY TWENTIETH CENTURY

DAVID CRAVEN

**M**exico's marked cultural diversity remains one of the most remarkable and challenging facts about this large Latin American nation for any foreigner to grasp. The enormous range in art and culture of this highly diversified country defies one-dimensional stereotypes perhaps more than any other nation of the Americas. In fact, the cross-cultural and transregional richness of Mexico, in conjunction with *La Revolución's* explosive impact after 1910, helps to account for the unsurpassed position assumed by art from Mexico during the first half of the twentieth century. From the early 1900s through the 1960s Mexico City was quite simply the Paris of Latin America, and even the preeminent art capital of the entire Western hemisphere.

Modernist art on this side of the Atlantic began in Mexico during the aftermath of the revolution, much more than in the United States at a comparable date. As is now clear, the all-important WPA public arts programs in the U.S., which later gave rise to the New York School in the postwar period, were deliberately modeled on the earlier and even more successful arts programs instituted by left-wing Mexican federal governments from the administration of Alvaro Obregón (1920–1924) through that of Lázaro Cárdenas (1934–1940). Whether as a stimulus or as a foil, the various modernisms of Mexican art, especially as showcased through the Mexican Mural Renaissance, set the terms for almost all the important modernist developments in the arts throughout the whole hemisphere from the early 1920s through the 1950s.

Along with mentioning the pivotal role of progressive public policy in Mexico for sanctioning innovative developments in the visual arts during the first half of the twentieth century, we should take note of the cultural diversity of Mexico even before, and certainly since, the revolution. In reality, Mexico comprises several "nations" at once, all of which are uneasily fused into a semiunified whole. Contrary to many common assumptions now about the top-down power of the federal government in Mexico, what one often sees instead is considerable regional autonomy, which in turn varies notably among the thirty-one different states making up the nation. This situation attests to the limited reach of centralized authority, the lack of any one uniform cultural tradition for the country

[R]evolutionary Mexican paintings—the most vital and imposing art on this continent in the twentieth century.

—MEYER SCHAPIRO (1937)[1]

In the 1930s, for many radical artists and intellectuals throughout the world, it was Mexico and not Paris that stood for innovation in the arts. Artists in Mexico were seen to have challenged the authority of a Eurocentric aesthetic and asserted the values of a self-consciously post-colonial culture.

—VALERIE FRASER AND ORIANA BADDELEY (1989)[2]

as a whole. While Mexico is now the largest Spanish-speaking country in the world, more than 30 percent of its 100 million–plus population are Amerindians, many of whose first language is not Spanish. As such, many indigenous languages are still spoken as the native tongue—from Nahauatl, Quiché, and Zapotec to Otomi and Miztec, among many others—and local cultural traditions vary accordingly, sometimes dramatically.

Similarly, with a gross domestic product at present of almost one trillion dollars a year—which now ranks among the top dozen economies out of 200 nations worldwide—Mexico is characterized by some exceedingly dense urban concentrations, despite the frequent rural cast of its cultures for the majority. The now legendary expanse of Mexico City, with a population of more than twenty million, makes it perhaps the largest metropolitan area in the world. Yet vast areas of rural labor and a vital tradition of artisanship, along with the ongoing frequency of subsistence farming in some places, play a significant role nationally. Indeed, the plethora of popular cultural practices in Mexico with their agrarian tenor still often provide the dominant cultural tone from region to region, even as the city remains the cultural capital. City versus country tensions, concomitant with a stark class-based hierarchy that was attenuated but not eliminated by the Mexican Revolution, distinguish Mexican social life at present.[3]

All of this makes one observation evident: in few other nations today are the consequences of uneven development resulting from corporate capitalism's "globalization" (along with its subterranean link to the legacy of colonialism) so obvious, its divisive social effects so clear. Side-by-side in some instances, forms of labor exist that extend from those of the sixteenth century to those of the twenty-first. These clusters of different periods in history coexist uneasily in what has been called a *temporal mestizaje,* and it makes any linear survey of Mexican culture far too reductive, much too homogenizing to possess fail-proof explanatory clout, however understandable our need to order art history into a manageable continuum.

The celebrated Mexican novelist Carlos Fuentes put the challenge for scholars as follows in the early 1990s:

> The European author writes with a sense of linear time, time progressing forward as it both directs and assimilates the past . . . . In Mexico, on the contrary, there is not and never has been one single time, one central tradition as in the West. In Mexico, all times are living, all pasts are present. . . . The coexistence in Mexico of multiple historical levels is but the external sign of a deep subconscious decision made by the country and its people: *all times must be kept alive.*[4]

This conception of history as a delta, rather than as a superhighway with only one destination that terminates in the West, is a key way to begin mapping the multiple identities, as well as conflicting class positions, articulated by various modernist movements from Mexico. Moreover, such a move helps us to gauge the proper measure in art of *lo Mexicano*, or of so-called *Mexicanidad* (Mexicanness)—an ideological construction that generally concerns only those facets of Mexican social life that involve historical continuity, such as cultural practices in relation to distinctive geographic factors. Yet this concept of an essential Mexicanness hardly accounts for all those other defining features of Mexican life that revolve around issues of historical discontinuities, as well as class-derived and ethnic-linked dislocations on the international stage beginning with *La Conquista* and gaining renewed momentum with *La Revolución*.

Significantly, the greatest event in contemporary Mexican history, one that supposedly unified the country as a nation-state, was one that in fact also had the opposite effect to a comparable degree. This was due to a new type of artistic pluralism that was a direct consequence of the Revolution of 1910, along with the remarkably radical constitution of 1917 and what it meant for reasserting relative autonomy in international terms. About these sometime unifying yet frequently diversifying social forces, the noted author Carlos Monsiváis has observed that "between 1910 and 1940 the cultural changes generated by the Mexican Revolution were extraordinary. It overturned the social order, brought new actors onto the stage, and provoked vast transformations of thought...and generated a progression of various movements [in the visual arts]."[5] Yet simply acknowledging the overlapping nature of competing, or even contradictory, historical traditions—and how the revolution intensified awareness of them—does not in-and-of itself help us to explain how the new relationships of these "simultaneous pasts" were notably altered by postrevolutionary policies. Nor does such a concession prepare us for explicating contemporary efforts on behalf of an even more radical reconfiguration of these coexisting temporal coordinates—such as one sees in the Chiapas Revolution since 1994 in one of Mexico's southern and most indigenous states.

What can we do methodologically, so that we both recognize the resurgence of various pasts and yet grapple at the same time with how the deck of cards denoting them was significantly reshuffled in the modern art of Mexico from roughly 1910 to 1950. After all, this historic reshuffling led to greater parity between Eurocentric and non-Eurocentric cultural practices, as well as between the neocolonial and anticolonial traditions vying with each other for a claim on the popular imagination in the last century.

We can begin by debunking two fallacies by means of the diverse artistic tendencies represented in this exhibition of paintings, which demonstrate a notable range of visual

languages and equally divergent ideological projects linked to them. In artificially homogenizing modern Mexican history, thus rendering it easily compatible with standard art history surveys, these stock-in-trade misconceptions of mainstream historians include the "fallacy of a monolithic Mexican state" beginning in the 1920s and the "fallacy of one nationalistic set of 'revolutionary ideals' made transparent to 'the people' in art" since the 1920s, thus seeming to give the nation-state a uniform national narrative. These two fallacies have their basis in a form of populism that often has little to do with popular self-empowerment. Mexican critic Cuauhtémoc Medina summed up their misguided impact when he complained of how Mexican artworks from the early twentieth century to the present now "live by the fraud of their transparency."[6]

One of my hopes is that this exhibition of art from Mexico, which is not easily reducible to something called Mexican Art, will help to restore a sense of the historical opacity, or at least density of history, within the visual arts during the period being revisited. Therefore, in this essay, I will analyze in a multilateral manner the symptomatic groups of artworks from Mexico in this current exhibition to showcase a far more complex and contradictory picture of the divergent national trajectories that have occurred in the wake of the Revolution of 1910. Today the various directions for development presented by competing trajectories constitute more a series of challenges to the nation's diverse constituencies than any so-called national destiny.

Unlike the popular nationalism (or better, popular national self-determination) linked to much of the significant art from Mexico in the early 1920s, the official nationalism championed by the PRI or PAN since the 1950s on the federal level presupposes something like a monolithic view of culture within the nation-state—a view one also sees naively assumed about Mexico in the mass media of the United States, as well as by tourists from this country.[7] And, indeed, this stereotypical conception of the Mexican state as an authoritarian Hobbesian "Leviathan" at the national level, which the major art (especially the public murals of, say, Diego Rivera) purportedly reflected, has been definitively refuted by postrevisionist scholars.[8] As Alan Knight, Linda Hall, and Mary Kay Vaughan, among others, have demonstrated, the revisionist authors of Mexican history erroneously extrapolated their paradigm of a strong central state from the Mexican situation since the 1960s and then simply imposed it upon an earlier and generally unrelated period of history. These revisionist historians have done so without understanding that the patronage of the Mexican state during the 1920s and 1930s was hardly a Leviathan formation towering above society and engineering artistic production on behalf of some singular ideological project.[9]

In her exemplary postrevisionist study of 1930s Mexico titled *Cultural Politics in Revolution,* Vaughan has provided the parameters for a "decentered" conceptual framework and a more nuanced approach to art than revisionism does:

Neither top-down analyses of nation creation nor modernization theory work for Mexico because of the character of that country's revolution. The revolution of 1910 destroyed the preexisting state, and it took three decades to build a new one. The new one was constructed through dialogue with diverse sociopolitical movements. It emerged from bitter negotiation between actors at national, regional, and local sites where power was disputed and developed . . . . the real cultural revolution lay not in the state's project but in the dialogue between state and society that took place around this project. . . . If the school functioned to inculcate a state ideology for purposes of rule, it also served communities when they needed to contest state policies.[10]

## THE INITIATORS OF THE DISCURSIVE FIELDS FOR MODERNIST MOVEMENTS IN MEXICO

Several of the key painters in this exhibition signed a groundbreaking 1923 Manifesto of the left-wing Union of Technical Workers, Painters, Sculptors, and Printmakers (SOTEP), which was allied to the Mexican Communist Party. In this manifesto, they both called for the socialization of art and repudiated easel painting or cabinet painting (*la pintura llamada de cabellete*) in favor of monumental murals (*arte monumental*).[11] Yet, as their easel paintings in this exhibition make clear, these artists—Diego Rivera, José Clemente Orozco, David Alfaro Siqueiros, Carlos Mérida, and Fermín Revueltas—were unable to stop painting in modest size on canvas or Masonite. Indeed, these small portable paintings actually helped to subsidize their politically *engagé* fresco paintings at a time when the government patronage of the wall paintings amounted to little more than minimum wage. Moreover, this "bourgeois art form" also allowed these artists either to experiment with ideas that were subsequently destined for public murals or to rethink motifs that had earlier appeared in images on government buildings.

Among the average-sized paintings on display that were preparatory stages for murals are some outstanding examples by *los tres grandes* (the three great ones), who initiated the main discourses of early "cosmopolitan modernisms": Diego Rivera (1886–1957), José Clemente Orozco (1883–1949), and David Alfaro Siqueiros (1896–1994).

To see just how dramatically Diego Rivera expanded the visual languages (or discursive fields) for muralism in Mexico, we need only view two of his paintings of anonymous women from the popular classes, one relaxing energetically and the other working distractedly. The first, *La bañista de Tehuantepec* (The Bather of Tehuantepec; plate 3) of 1923, was done after a couple of trips to traditional Mayan regions in the extreme south of the nation, those of the Yucatán in 1921 and the Isthmus of Tehuantepec in 1922. This supple seminude served as a preparatory image for some of the figures in celebrated fresco panels of the Ministry of Education in Mexico City. The earthy, unabashed sensuality of this image of an Amerindian woman in profile shows her absorbed in her own

intimate and fleeting activity, while being oblivious to the spectator. As such, this affirmative painting of an ephemeral event without a hint of coyness represented in the early 1920s an unusually non-Eurocentric conception of physical beauty, one without the staged quasimetaphysical air that characterized more "timeless" academic renditions of Mexican women during this period.

Two noteworthy paintings in the exhibition are examples of the conventional trends in Mexico, thus serving as foils for the more innovative painting by Rivera, and they were executed roughly contemporary with the Rivera image. On the one hand, there is the late symbolist *La criolla del mango* (Creole Woman with Mango; plate 1) of 1916 by Saturnino Herrán (1887–1918). Indebted thematically to Gauguin's depictions of non-European subjects, the elegant work by Herrán nonetheless features a neo-Baroque style and high-society finery with overtones of Van Dyck's courtly portraits, which makes it manifestly Eurocentric in formal values for all the Mexicanness of the subject.

On the other hand, there is the chaste monochromatic painting by Alfredo Ramos Martínez (1871–1946) of *Maternidad* (Maternity; plate 2), which is probably from 1924, before he had immigrated to the U.S. This handsome work is academic in the opposite direction, owing to its deliberate focus on the purported Indianness within Mexican culture. Based on a supposedly archetypical language with a striking intaglio-like look, the pan-Indian image by Alfredo Ramos Martínez reminds us of how much closer his conservative conception of *indigenismo* was to that of José Vasconcelos, author of *La raza cósmica* (1924), than was the "unstable" counterposition of Diego Rivera, for whom ethnicity was always being reconfigured as part of a larger historical process linked to class-based dislocations. Indeed, while he was director of the National School of Fine Arts (the Academy of San Carlos) from 1913 to 1914 and then again from 1920 to 1928, Ramos Martínez even contended in starkly essentializing terms that the "purer" the racial origins of the student, the "purer" their artworks would "spontaneously" be—as if biology and culture were somehow inextricably linked in ahistorical terms.[12]

What Mexican philosopher Alberto Híjar has perceptively termed the "alternative *indigenismo*" of Diego Rivera is to be seen in the superb canvas painting of a working-class Mexican woman, *La vendedora de pinole* (The Pinole Vendor; plate 4) of 1936.[13] Linking, as always, ethnic references with class location so as to anchor ethnicity historically, Rivera gives us here a painting that is as monumental in formal values as it is modest in actual scale. The subtle inclusion of the regional *jicara* (gourd) *metate* for preparing maize involves an ethnographic element that does not devolve into anecdotal topicality, as one sees in some of the other paintings in the current show. At once resonating with a deft color interaction and yet compositionally restrained by the modernist spatial tension between two dimensions and three, this painting by Rivera contains no "cute" details that would detract from the sober feel of an image that underscores the dignity of this Mexi-

can woman without denying the austere setting for her labor. The sophisticated simplicity of Rivera's language is one that almost effortlessly enjoins a pictorial form of painting from "high culture" with a sensibility from the popular classes. Here as elsewhere, there is in Rivera's best work a dialogical interplay of high and low, of Western and non-Western that marks it off as a dynamic form of alternative *indigenismo* in line with the philosophical stance of Peruvian thinker José Carlos Mariátegui.[14] The latter figure both identified with the art of Rivera and criticized (as did Rivera himself) the conservative form of *mestizaje* championed by José Vasconcelos, who was Rivera's patron in the Ministry of Education from 1921 to1924.

A related example of alternative *indigenismo* with even more emphatic class-based overtones of exploitation is of course the baldly titled *Madre proletaria* of the late 1920s, an oil painting by David Alfaro Siqueiros, which provides an emotionally charged visual counter to the harmonious detachment, or gentle sentimentality, of Alfredo Ramos Martínez's *Maternidad* (plate 2). Here as elsewhere in his oeuvre, Siqueiros insisted on underlining the contemporary desperation of the indigenous woman's circumstances, over and above any general traits that would deflect our attention from a concrete social situation of oppression. Indeed, the jutting polyangular pictorial space occupied by the disenfranchised working-class mother and her disfurnished child makes the image as visually urgent as the social predicament being addressed thematically by Siqueiros.

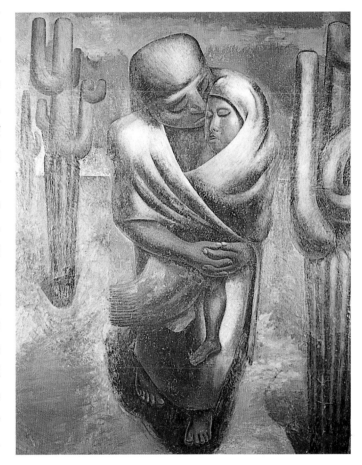

JOSÉ DAVID ALFARO SIQUEIROS
*Madre proletaria* (Proletarian Mother), c.1924
Oil on canvas.
Courtesy Museo Nacional de Arte

These varied images also remind us of an astute analytical point about the plurality of visual languages (or visual discourses) that were used during this period. As art historian Justino Fernández pointed out about the twentieth century, linear classicism and painterly Baroque did not form a successive sequence of period styles in Mexico, as Wölfflin had famously discussed them in Europe. They were instead an ongoing set of vital visual languages that were periodically renovated along regional and personal lines, all in conjunction with the introduction of yet other languages as well. Later additions brought into the mix included both precolonial and postcolonial visual traditions, from the "Anáhuac Cubism" of Rivera, through a trans-Atlantic expressionism with filiations to modernist German art used by Orozco, to the reverberating combination of ultra-baroque with Italian Futurism by Siqueiros. Thus, Rivera was a modernist renovator of classicism and Orozco, along with Siqueiros, was simultaneously a modernist renovator of baroque art.[15]

Among the splendid portraits in the show is the one of Guatemalan art critic Luis Cardoza y Aragón, who, like Justino Fernández, considered Orozco to be the culminating

painter of the entire Mexican School (plate 13). In fact, this commanding painting from 1940 was done at the same time that Cardoza y Aragón was finishing *La nuba y el reloj* (The Cloud and the Clock), his well-known book about seven painters from Mexico, all of whom are represented here. In this study, he gives a textual portrait of Orozco, which helps to illuminate key formal attributes of the pictorial portrayal that we see here. The aesthetic reasons for Orozco's singularity consisted of his uncommon skill in establishing an *"equilibrio entre lo abstracto y lo concreto"* (an equilibrium between the abstract and the concrete) through a *"belleza convulsiva"* (convulsive beauty) that generates unmatched intensity based on how *"su emoción es impersonal"* (its emotional power is impersonal).[16] The painting is thus pervaded by an *"orgullosa humilidad"* (proud humility) that almost gives rise to a *"cierta truculencia"* (certain truculence) and definitely results in Orozco's being *"el único poeta trágico"* (the only tragic poet) of international significance produced by the Americas. This said, the author concluded: *"No le interesa ser mexicano"* (He was not interested in being merely a 'Mexican' artist).[17]

The portrait of Cardoza y Aragón by Orozco (plate 13), which he executed in tempera on canvas, features somber colors of brooding, low intensity from low-value reds like mauve to grayish blue. A tense figure-ground relationship emerges from the spatial flatness and neutral tones in the background. Nevertheless, the work as a whole is animated by energetic, if chalky, highlights that recall those of El Greco and that frame the head like a chiliastic halo. Other dark green highlights on the face make the eyes seem deeply inset in a way that strongly contrasts with the overall impetus to background flatness, owing to tonal values. The 1934 portrait by Siqueiros of Eve Mayers (plate 14) possesses some of the same sobriety and much the same humorless intensity as the portrait by Orozco.[18] It is as if the subject of Siqueiros's portrait is incapable of blinking. This painting embodies in a literal way the desire to look unflinchingly into the future, which was the avowed aim of Siqueiros himself.

Yet another genre that was notably renovated in the easel format by *los tres grandes* is that of landscape, of which there are characteristic paintings by both Orozco and Rivera in the show. *Colinas mexicanas* (Mexican Hills; plate 11) from 1930 by Orozco shows his expressionist language at its most grim. He has used a set of converging diagonals that in turn triangulates the painting as a whole. This configuration is then echoed by the sharp edges of the maguey plants in the foreground. Counterbalancing these edgy qualities, which were a staple element in modern Germany of *Die Brücke* compositions, are the brute geometry of a rural dwelling and the passive positions of two women in the left foreground. Again, the deep, melancholic colors contrast starkly here with the broad chalky passages of the façade and other elements within the overarching vortex of the painting. Orozco elicits a forlorn feeling that does not fade easily.

Rather different yet quietly haunting in its own way is the spectral landscape with Goya-like popular overtones by Diego Rivera titled *Paisaje nocturno* (Night Landscape; plate 6) from 1947. With its unearthly yellow lighting of *campesinos* seated in trees at night, as if to gain protection from some nocturnal threat on the ground, the painting uses figures (youths?) in popular clothing in a way that recalls the capes and vernacular hats of Goya's *majo* images. Done in the postwar period, when an anxious alertness was the hallmark of the day, this painting by Rivera exudes a sense of angst through the almost supernatural way in which the scene is illuminated. Interestingly enough, the cinematic or almost Hollywood-like usage of what could be artificial lighting has led some scholars to speculate that Rivera was inspired to paint this composition after seeing spectators perched in trees at night to watch the filming of a movie in Tampico, Mexico, by John Huston. Yet, whatever the incidental stimulus that triggered the painting, *Paisaje nocturno* is one of the most captivating landscapes done by Rivera in the mid-twentieth century.[19]

To mention modern landscape painting from Mexico is, of course, to think of paintings by Dr. Atl (or Gerardo Murillo Cornado, 1875–1964), and  a fine example of his approach appears in the exhibition: *Nubes sobre el  Paricutín* (Clouds above Paricutín; plate 9), from around 1942. It deals with volcanoes, a topic about which he wrote a book that fused geology with spiritualism, and the painting reminds us of how tied to the nineteenth-century tradition of panoramic realism his majestic representations of mountains really are. As this depiction of volcanoes indicates, Dr. Atl believed that these geological phenomena embodied various facets of the human spirit. Certainly the mood of this landscape divulges quite varied sets of emotional associations, from the dark and forbidding to the radiant and upward ascending. The tightly linear language employed, though, so nineteenth century in sensibility, reminds us that Dr. Atl belonged to an earlier generation of academic painters; he was, in fact, a valued mentor of *los tres grandes,* however much they took divergent paths from the one he pursued.

As the overall show demonstrates, the modernist discursive fields laid out by the three main muralists resonated powerfully with younger artists from throughout Mexico for many decades. In making this observation, one needs to take a page from Michel Foucault, so as to go against any view of Rivera, Orozco, and Siqueiros as Nietzschean-like *Übermenschen* towering above history within a so-called great man theory of art history. At issue here is something closer to what Foucault meant in "What Is an Author?" when he identified key "initiators of discursive" languages, such as Marx and Freud. These figures "established a possibility for further discourse" by broadening the terms of inquiry much more than had other "authors" or "artists."[20]

Much the same can be said about Rivera, Orozco, and Siqueiros, as many paintings in this show by other artists from Mexico make so obvious. To survey the entire exhibit is

to see echoed with varying degrees of success—but consistently at a skill level that is remarkably high—how powerful the example of *los tres grandes* was, albeit in diverse ways. Paintings of death by Orozco, one of the first of the *catastrofistas* (painters of catastrophes), were definitely the point of departure for the memento mori painting by Guillermo Meza (1917–1997).[21] Similarly, Rivera's signal innovations in muralism during the 1920s enjoyed a considerable afterlife, as shown by the two paintings of panoramic landscapes by Fermín Revueltas (1902–1935), both of which derive thematically as well as formally from Rivera's frescos of the 1920s in the Ministry of Education and at Chapingo. The somberly impressive 1948 *Francisco I. Madero* by Rufino Tamayo (plate 41) is linked to a portrayal of Madero the previous year in Rivera's great public mural about Sunday afternoon in Alameda Park, just as the genre painting by Emilio Baz Viaud, *El peluquero zurdo* (The Lefthanded Hairdresser; plate 50) of 1949 shows both a certain debt to Rivera and yet considerable distance from his approach, owing to the anecdotalism and sentimentalism that mark off the later images by Baz Viaud from Rivera's above-noted genre paintings of the 1920s and 1930s.

## LAS TRES GRANDES OF COSMOPOLITAN MODERNISMS IN MEXICO

If the importance of *los tres grandes* is incontrovertible, much the same can also be stated about *las tres grandes* from the first half of the twentieth century in Mexico, namely, Tina Modotti (1896–1942), Frida Kahlo (1907–1954), and María Izquierdo (1906–1955). Here again the current exhibition of their works and those of other artists indebted to them underscores their significance as initiators of modernist discourses in Mexico and beyond. Until relatively recently, their considerable impact on the art world has been strongly understated, except by a few specialists. Now, though, Modotti and Kahlo have come to enjoy celebrity status on the international scene to such an extent that images of Frida in mass culture of the Americas probably rank second in number only to those of revolutionary icon Ché Guevara, with whom Kahlo would have been in complete sympathy politically.

In their own lifetimes, each of these artists enjoyed critical praise, especially in Mexico City, even though they also felt embattled at various moments as artists simply because of their gender. All three women artists were singled out for admiration either in print or in public talks by Diego Rivera, whose own susceptibility to *machismo* made it clear that the admiring remarks about their artistic accomplishments were sincere ones. In one of the first published essays about Modotti's photographs, Diego Rivera wrote the following in 1926:

One day when we were looking at their work, I said to Edward Weston and Tina Modotti: "I'm sure that if Velázquez were born again he would be a photographer." Tina and Weston replied that they had already thought the same.... Edward Weston now embodies best the artist of America, namely, he whose sensibility contains the extreme modernity (*modernidad*) of art from "el norte" and the vital tradition that has emerged from "el sur." Weston's student, Tina Modotti, has achieved marvels of sensibility on perhaps an even more abstract or intellectual plane, as is natural for an Italian temperament whose work flourishes perfectly in Mexico and agrees so precisely with our impassioned sensibilities.[22]

The corpus of Modotti's photographs, two of which are in the exhibit, was small, but their significance is great. Almost all of her photos were taken between 1923 and 1929 in Mexico, though she was born in Italy and subsequently lived in the U.S. before she moved back to Europe and then returned to Mexico City where she died in 1942. She was at once a cutting-edge cosmopolitan modernist, like her mentor Weston, and an *engagé* artist in the most profound sense. Thus, she embodied in an uncommonly compelling manner the modernist as political activist. As such, her photos are at once aesthetically lean and ideologically dense.

The distinctively concentrated focus in them rivals the images from 1920s Russia by Alexander Rodchenko or Dziga Vertov; one sees it in her minimalist *Cañas de azúcar* (Sugar Cane; plate 22) of 1929 or in the frankly sensual *Niña tomando pecho* (Infant at Her Mother's Breast; plate 23) of 1929. What distinguishes these so-called decontextualized photographs (to cite a crudely misguided criticism of modernist photos that are not "documentary") from most other images outside of the Soviet Union during this period is the sober and unsentimental focus on basic popular cultural or vernacular elements of the working classes. These components are then articulated by means of a language grounded in a cosmopolitan modernism connected to the avant-garde group named *Estridentismo* (1921–29), for which she produced some very "abstract" photos, like *Telephone Lines* (1925). Her photos are neither didactic nor single-minded about their political import, since their minimal language makes them polyvalent as "signs," thus ideologically loaded. The image *Cañas de azúcar* in Mexico certainly existed in an ideological field of this era that knowingly associated it with the major type of cash crop grown on the repressive haciendas against which the Zapatistas revolted in Morelos. This made the photo at once ideologically charged but not politically explicit.

Because Edward Weston, one of the defining figures of early modernism in the history of photography, was her teacher, the two artists are often compared. Certainly the

two silver gelatin photos by Weston in the exhibit—*Dos garzas de laca de Olinalá, México* (Two Herons in Lacquer of Olinalá; plate 24) of 1924 and *Lavabo y aguamanil* (Lavatory and Basin; plate 25) of 1926—are masterful in their austere elegance and in their subtle references to popular culture. The conventional view up through the 1950s, which Octavio Paz voiced as late as 1963, simply relegated Modotti's photos to the status of "derivative" in relation to Weston's. Later, feminist critics, such as Laura Mulvey and Margaret Hooks, rightly disputed this unfair and unflattering contrast. Yet they sometimes have done so merely by inverting the judgment against Weston, in order to bolster the case for Modotti. However unavoidable such a comparison and contrast is, owing to their student-teacher relationship, little is gained by denigrating one in order to inflate the standing of the other. In fact, as the images in the show demonstrate, both are of fundamental importance in the history of photography (as Diego Rivera clearly admitted in 1926), whatever we conclude about the relative merits of either.

The second member of this triad of women modernists in the art history of Mexico is Frida Kahlo, over a decade younger than Modotti and five years the junior of María Izquierdo. Her greatness as a portrait painter is not in question, especially concerning her exceedingly intense self-portraits, which number at least fifty in an oeuvre of no more than two hundred paintings. Among artists of the early twentieth century, she was indeed respected as the equal of Van Gogh when it comes to self-portraits. Both Diego Rivera and Pablo Picasso, the latter seldom known for his humility, praised Frida Kahlo's portraits as virtually unsurpassed. As Picasso wrote in a letter to Rivera after seeing an exhibit of her paintings in Paris in the late 1930s, "Neither Derain nor I nor you are able to paint a head like those of Frida Kahlo."[23]

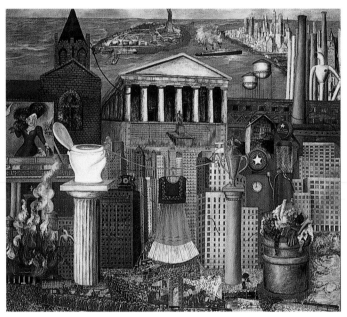

Another issue revolving around Frida Kahlo's locus in art history is in doubt and is often debated, that is, whether or not she was a Surrealist. André Breton and other members of this Paris-based group, who in the 1930s organized shows of her paintings in New York City and Paris, claimed her as one of their own. Other scholars, motivated by Kahlo's flippant declaration that she did not know she was a Surrealist "until Breton told her she was," have asserted that she was *not* a Surrealist because that was not her *conscious* intent. Such a disagreement, though, misses the point, if being a Surrealist was something triggered by the unconscious quite aside from the artist's rational intentions. Perhaps a more pertinent question to ask concerns the distinctive pictorial logic of her collage-like compositions not in the show, such as *Allá cuelga mi vestido, Nueva York*, 1933–38 (There Hangs My Dress, New York), which features both oil and collage elements on Masonite. What is the formal

logic responsible for this image? Does it relate to the formal logic that was peculiar to Surrealist artworks, whether consciously or unconsciously, intentionally or not?

The answer to this question is a revealing one concerning the odd combination of outdoor landscape and domestic interior that is central to Kahlo's painting/collage.[24] In this image two artistic tactics for estranging us from rational perception obtain. First, impossible locations and/or uses of things abound, as when indoor toilets and sport trophies serve as outdoor clothesline poles among buildings of improbable dimensions—and this is what we could term *displacement*. Second, things like truncated classical columns and machine parts appear in fragmentary form, so that a part of a building or object represents the whole—and this is what we could call *condensation*. Taken together these two maneuvers constitute key operations of what Freud called unconscious "dreamwork." As such, he wrote of how the crazy or irrational occurrences in dreams actually have a structural logic, or at least a syntax, that allows the dreams to be decoded rationally. Thus, two primary Surrealist devices for composing images in a manner consistent with dreamwork (displacement and condensation) are actually two of the most symptomatic compositional gambits of Kahlo's works. Whether she consciously intended them to be or just unconsciously acceded to them while painting intuitively does not annul this surreal feature of her work. An elective affinity with Surrealism is there, even if unwilled.

Somewhat similar points can be made about the remarkable still-life painting by Frida Kahlo that is in the current show, *Los cocos* (The Coconuts; plate 29) of 1951. This compelling painting features an anthropomorphic presentation of fruits that exude animistic overtones. As such, we see examples of flora that possess a totemic relationship to humans, which was, after all, a favorite preoccupation of the Surrealist movement.

The third major woman artist from this formative era in the art of Mexico was María Izquierdo, probably the most well known of the three inside Mexico, at least until recently, yet certainly the least widely recognized outside of Mexico. Her entry into the Mexican art world was dramatic and improbable. The obstacles she overcame were formidable ones. Forced into an arranged marriage when she was only fourteen, Izquierdo abandoned her family after a decade of being a mother in order to study at the National School of Plastic Arts, just as Diego Rivera, the director, radicalized the whole program at the Academy of San Carlos. In 1929, a big controversy arose when, after doing studio critiques of all the student work there, Rivera declared that María Izquierdo's works demonstrated that she was the "only real artist" to have emerged to date. He then helped her to secure a show at the Galerie de Arte Moderno of the Teatro Nacional and wrote an essay praising her work. The opposition she encountered from this bastion of entrenched male privilege led her to write that in Mexico, "It's a crime to be a woman, [but] it's an even greater crime to be a woman and to have talent."[25] Yet this episode and the hard-earned career she carved out for herself indicate just how paradoxical her situation was: it was

both a testament to the gains of women in the aftermath of the Mexican Revolution and a sober indicator of just how elusive greater emancipation for women remained.

Izquierdo's paintings in this exhibition are quite impressive, from the sharp yet dreamy 1940 portrait of an unknown sitter entitled *Mujer Oaxaqueña* (Woman from Oaxaca; plate 31) to the two commanding variations on genre painting, one of which is an interior with *alacena* (open cupboard), whose roots are in the colonial period. *El Alhajero* (Jewelry Box; plate 30) of 1942 features a densely intertwined composition of intimate clothing items and jewelry balanced by an oddly placed open umbrella, all of which is deftly painted in shrilly high-value hues and with a chilly admixture of chalky highlights. A singular atmosphere emerges that is at once intimate and detached, both proximate and distant at the same time. Equally impressive is her 1952 oil on canvas painting *Viernes de juguetería* (Friday in the Toy Cupboard; plate 33), which playfully displays familiar objects and then defamiliarizes the spectator with them through the unique mood that pervades her painting. Quotidian objects from popular culture become thereby a means to go beyond everyday perception.

As was true of the three main muralists, so *las tres grandes* of easel painting enjoyed a considerable impact on the subsequent discursive fields of Mexican visual art, as evidenced by the artworks of over a half dozen figures in the show. The great photographer Manuel Álvarez Bravo (1902–2002) was mentored by Tina Modotti in 1927, and he then produced an extraordinary body of work that consolidated some of the directions mapped out by Modotti, while also discovering new ones. Alvarez Bravo's four works in the show are all impressive, but *La hija de los danzantes* (Daughter of the Dancers) of 1933, with its complex formal play involving the act of a person looking through a portal as we try to decipher the image perceptually, is simply a masterpiece.

Frida Kahlo's influence on the discursive practice of later artists is quite clear, for example, in several images: the surrealist-inspired painting *Deseo* (Desire; plate 45) of 1936 by Carlos Orozco Romero, which followed her lead; and the 1935 surrealist or magical realist painting by Gabriel Fernández Ledesma entitled *Interior sin personajes* (Interior without People; plate 48). Similarly, one can see the deep impact of María Izquierdo on art from Mexico in this period in paintings by Olga Costa, such as *La novia* (The Girlfriend; plate 35) of 1941 or *Retablo* of 1942 (plate 36) and in the paintings by Alfonso Michel, for example, *Mujer con manto blanco* (Woman with White Shawl) of 1941 (plate 54) or *Bric a Brac* of 1954.

## LOS CONTEMPORÁNEOS, PAINTERS OF MEXICANNESS VS. COSMOPOLITAN MODERNISTS

The six *grandes* discussed so far often faced charges from contemporaries of being "un-Mexican" from the 1920s through the 1950s. Such was particularly the case with Rivera,

ever the lightning rod for controversy. A patron of the period has written of the ideological differences dividing artists in Mexico. He noted that the younger artists in Mexico, specifically those of the nationalistic group entitled *Contemporáneos* (1928–32), who were dedicated to an apolitical Mexicanness or *lo Mexicano*, were critical of the muralist:

> Young men in Mexico are likely to say that Rivera is a classical painter...that the appearance of "Mexicanism" in Rivera's painting is accidental....They said he was un-Mexican...and untruthful about [class-conflict in] contemporary life.[26]

The conservative but quite influential group of artists belonging to *Contemporáneos* emerged from the *Movimiento Pro-Arte Mexicano* (The Pro-Mexican Art Movement) that drew its conception of *lo Mexicano* from the centrist position of José Vasconcelos and his protégé, Alberto Best Maugard, who was director of drawing in the Ministry of Education during the twenties. The Mexicanist coterie of painters included Manuel Rodríguez Lozano (1897–1971), Abraham Ángel (1905–1924), and Rufino Tamayo (1899–1991), all of whom are represented by key paintings in the show, plus other artists such as Agostío Lazo and Julio Castellanos. The group was committed to an art of national unity centered on an essential Mexican character supposedly found in "innocent" popular art forms. Accordingly, they sought to highlight the attractive features of national life, especially "'pretty' aspects of popular culture."[27]

Those engaging aspects of Mexican culture are in evidence in the late Symbolist paintings by Ángel in this exhibit and in the youthful *Cadete* from 1923 (plate 55), with its homoerotic undercurrents. The latter trait markedly distinguished the paintings of *Los Contemporáneos* from the macho extroversion of images by *los tres grandes*.

Yet, there are also alarming consequences of this nationalistic art program, whose ethnocentric overtones are so emphatically at odds with the cosmopolitan modernisms of the six main painters from Mexico discussed above. We need only ponder two paradigmatic works for the entire group: Agustín Lazo's *Vista de Morelia* (View of Morelia) from 1937, which is not on exhibit in the current show, and Manuel Rodríguez Lozano's *El pensador* (The Thinker; plate 37) of 1935.

The first painting, the landscape by Lazo, uses a visual language of "vernacular modernism" that was favored by the Italian fascists, particularly Mario Sironi, whose *White Horse and Pier* of 1920 clearly provided a formal antecedent for Lazo's image. It is probable that Lazo actually met this fascist leader and prominent painter when he was living in Europe from 1922 to 1930 at the time of Mussolini's consolidation of power. The contradiction here is instructive. Virtually everything about this purely Mexican painting by Lazo—the exaggerated use of one-point perspective, the nostalgia for imperial classical

art, the pretty palette with "lines of force" cross-hatching, and the focus on heroic statues in public places, along with the atmosphere of mysterious longing—in fact comes from the metaphysical paintings of Giorgio de Chirico, who was a key resource for fascist ideologues like Mario Sironi.[28] Here as elsewhere an effort to transcend politics through nationalistic mythmaking ends up descending into ultra-right-wing ideological values, whether in Italy or in Mexico.

Much the same about fascist lineages can be said of the heroic nude males located near a national monument of the imperial past in Mexico that we encounter in Manuel Rodríguez Lozano's painting *El pensador* (The Thinker). The visual language here was in fact virtually the same one on display in Nazi Germany, as anyone familiar with the sculpture of Arno Breker at the Venice Biennale in the mid-1930s would know immediately. Nor should we forget that the main patron in Mexico of *lo Mexicano* in art was José Vasconcelos, who discredited himself in the 1930s by making pro-Nazi remarks that startled progressive people throughout Mexico. Significantly, major scholars like Renato González Mello have recently begun to analyze these fascist undercurrents in other art works from this period in Mexico.[29]

We should not, however, close this wonderful survey of art from Mexico, which is on exhibit in Santa Fe, without singling out some outstanding paintings by two Mexican artists from the post-muralist generation who pursued a different path. They personally knew the *Contemporáneos* painters but did not produce either nationalistic art or ethnocentric images of Mexico with fascist overtones and imperial visions. These two artists were Antonio Ruiz "El Corcito" (1897–1964) and Jesús Guerrero Galván (1910–1973). The former is represented by a masterful, if also small, oil painting entitled *Desfile cívico escolar* (Civic File of Students; plate 20) of 1936 that simultaneously celebrates popular mobilization and public celebrations of the militant Cárdenas years, while nevertheless making subtle reference to all the class tensions as well as ethnic divisions still pervading the nation even in a time of progressive change.

Guerrero Galván occupies a particularly important place in the history of New Mexico, as well as Mexico, since as an artist-in-residence at the University of New Mexico during 1942–43, he painted a large fresco about the antifascist and transcultural theme of pan-Americanism entitled *La Union de las Américas bajo la égido de la Libertad* (The Union of the Americas under the Aegis of Liberty). This work, which is on permanent display in Scholes Hall at UNM, is one that provides a larger frame within which to view his nonethnocentric and deeply humanist focus on Mexican culture as an extension of humanity more generally. Furthermore, Guerrero Galván's visionary fresco is a compelling reminder that great art always transcends borders of nation-states, thus causing us to imagine the day when national borders as such will no longer exist.[30]

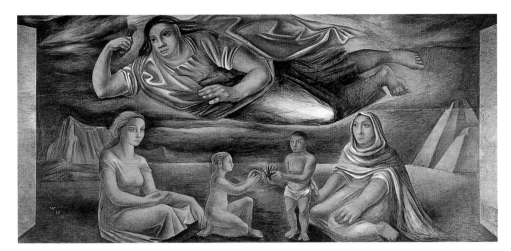

JESÚS GUERRERO GALVÁN
*La Union de las Americas*
(The Union of the Americas), 1943
Fresco, 2.5 x 5.3 m
Scholes Hall, University of New Mexico

NOTES

1. Meyer Schapiro, "The Patrons of Revolutionary Art," *Modernist Quarterly* 1, no. 3 (October–December 1937): 463. Meyer Schapiro was a friend of both Diego Rivera and Frida Kahlo, who visited him on several occasions when Rivera worked on the Rockefeller Center mural in the 1930s.

2. Oriana Baddeley and Valerie Fraser, *Drawing the Line: Art and Cultural Identity in Contemporary Latin America* (London: Verso Press, 1989), pp. 80–81.

3. As befits a nation with such a momentous role in modern world history, the scholarly literature on Mexico is enormous. Still the finest overall treatment of the twentieth-century developments examined here is the classic survey text: Michael C. Meyer, William L. Sherman, and Susan M. Deeds, *The Course of Mexican History* (Oxford: Oxford University Press, 1999), which is now going into its seventh edition.

4. Carlos Fuentes, *Nuevo Tiempo Mexicano* [1994](New York: Farrar, Straus, and Giroux, 1996), p. 16, emphasis added.

5. Carlos Monsiváis, "Perspectives on the Arts of Mexico," *Latin American Art Magazine* (Fall 1990): 25.

6. Cuauhtémoc Medina, "Irony, Barbary, Sacrilege," in *Distant Relations (Cercanías Distantes)*, edited by Trisha Ziff (New York: Smart Art Press, 1996), p. 100.

7. For a look at the stereotypical attitude toward Mexico, see James Oles, *South of the Border: Mexico in the American Imagination* (Washington, D.C.: Smithsonian Institution Press, 1993).

8. For an example of the now discredited revisionist thesis that the murals merely "reflected" the dominant ideology of the Mexican state, see Marí Carmen Ramírez, *The Ideology and Politics of the Mexican Mural Movement, 1920–1925* (Ph.D. dissertation, University of Chicago, 1989) and subsequent articles by the same author on Mexican muralism.

9. See, for example, Alan Knight, "The Rise and Fall of Cardenismo, c. 1930–1946," in *Mexico since Independence* (Cambridge: Cambridge University Press, 1991), pp. 241–55, and Linda B. Hall, *Alvaro Obregón: Power and Revolution in Mexico, 1911–1920* (College Station: Texas A&M University Press, 1989). A very recent examination of key primary documents concerning state patronage in Mexico during the 1920s has revealed just how divided the government officials in Mexico were over the goals and even the merits of the Mexican Mural Movement. See Patrick Schaefer, *The Contingency of State Formation:*

*Diego Rivera and the Political Currents of Postrevolutionary Mexico, 1922–1924* (Master's thesis, University of New Mexico, 2005).

10. Mary Kay Vaughan, *Cultural Politics in Revolution: Teachers, Peasants, and Schools in Mexico, 1930–1940* (Tucson: University of Arizona Press, 1997), pp. 9–10.

11. *Manifiesto del Sindicato de Obreros Técnicos, Pintores y Escultores,* in Raquel Tibol, *Palabras de Siqueiros* (Mexico City: Fondo de Cultura Economica, 1996), pp. 23–25. This manifesto was written primarily by Siqueiros in 1923 and then published in Number 7 of *El Machete* (June 1924).

12. *Monografía de las Escuelas de Pintura al Aire Libre y Centros Populares de Pintura* (Mexico City: Editorial Cultura, 1926), p. 9. See also: Karen Cordero Reiman, "Alfredo Ramos Martínez: Un pintor de mujeres y de flores ante el ámbito estético posrevolucionario (1920–1929)," in *Alfredo Ramos Martínez: Una visión retrospectiva* (Mexico City: Museo Nacional de Arte, 1992), pp. 66–75.

13. Alberto Híjar, "Diego Rivera: contribución política," *Diego Rivera Hoy* (Mexico City: Palacio de Bellas Artes, 1986), pp. 37–72. A translation of Híjar's outstanding essay by Dylan Miner, done in one of my seminars at UNM, will be published in a future issue of *Third Text*. For another look at the essentialism of official *indigenismo*, see David Brading, "Manuel Gamio and Official Indigenismo in Mexico," *Bulletin of Latin American Research* 7, no. 1 (1988): 75–89.

14. See David Craven, "Postcolonial Modernism in the Work of Diego Rivera and José Carlos Mariátegui: New Light on a Neglected Relationship," *Third Text* 54 (Spring 2001): 3–16. This was the first article to disclose the collaboration of these two celebrated figures in the 1920s.

15. Justino Fernández, *Arte moderno y contemporaneo de México*, 2 vols. [1952], introduction by Rita Eder (Mexico City: Universidad Nacional Autónoma de México, 1994). Eder discusses this point in her essay.

16. Luis Cardoza y Aragón, *La nube y el reloj: Pintura mexicana contemporáneo* (1940), presentation by Rita Eder and preliminary study by Renato González Mello (Mexico City: Universida Nacional Autónomo de México, 2003), pp. 259–312.

17. Ibid., p. 287. About Orozco's relationship to anarchism, see Alejandro Anreus, *Orozco in Gringoland: The Years in New York* (Albuquerque: University of New Mexico Press, 2001). For a rather different look at Orozco's politics, see: Renato González Mello, *Orozco ¿Pintar revolucionario?* (Mexico City: Universidad Nacional Autónomo de México, 1995).

18. On Rivera, see Rita Eder, "The Portraits of Diego Rivera," in *Diego Rivera: A Retrospective* (Detroit: Detroit Instutute of Arts, 1986), pp. 200–201.

19. For the discussion of the possible links to John Huston's filming of *The Treasure of the Sierra Madre*, see *Diego Rivera: catalogo general de obra de caballete* (Mexico City: Instituto Nacional de Bellas Artes, 1989), p. 232, no. 1782.

20. Michel Foucault, "What Is an Author?" [1969], translated by J. Venit, *Partisan Review* 42, no. 4 (1975): 611. Among the things *un*intentionally established by Foucault's essay is just how deeply indebted he was to the discourse about Marxism initiated by his own teacher, Louis Althusser.

21. Teresa del Conde, *Historia mínima del arte mexicano en el siglo XX* (Mexico City: Attame Ediciones, 1994), p. 28.

22. Diego Rivera, "Edward Weston y Tina Modotti," in *Arte y política*, edited and with an introduction by Raquel Tibol (Mexico City: Grijalbo, 1979).This essay was originally published in *Mexican Folkways* 6 (April–May 1926).

23. Raquel Tibol, *Frida Kahlo: An Open Life* [1983], translated by Elinor Randall (Albuquerque: University of New Mexico Press, 1993), p. 130.

24. Still the definitive work about Frida and a key reason that she has assumed such a prominent book in contemporary art historical circles is Hayden Herrera, *Frida: A Biography of Frida Kahlo* (New York: Harper and Row, 1983).

25. María Izquierdo, "Memoirs" [1953], document, Aurora Posadas Izquierdo Archive, Mexico City. First cited by Olivier Debroise, "El estudio compartido: María Izquierdo y Rufino Tamayo," in *The True Poetry*: *The Art of María Izquierdo* (New York: Americas Society, 1997), p. 52.

26. MacKinley Helm, *Mexican Painters* [1940] (New York: Dover, 1941), pp. xix, 136–37.

27. Karen Cordero Reiman, "Constructing a Modern Mexican Art," in Oles, *South of the Border*, pp. 21–31.

28. See Emily Braun, "Mario Sironi's Urban Landscapes: The Futurist/Fascist Nexus," in *Fascist Visions*, edited by Matthew Affron and Mark Antliff (Princeton: Princeton University Press, 1997).

29. Renato González Mello, "Los pinceles del siglo xx: Arqueología del régimen," in *Los Pinceles de la Historia: La Arqueología del Régimen, 1920–1955* (Mexico City: Museo Nacional de Arte, 2003), pp. 17–37.

30. For more on the iconography of this important mural, see David Craven," Jesús Guerrero Galván," in *St. James Guide to Hispanic Artists* (New York: St. James Press, 2002), pp. 266–67.

# Mexican Modern

MASTERS OF THE 20TH CENTURY

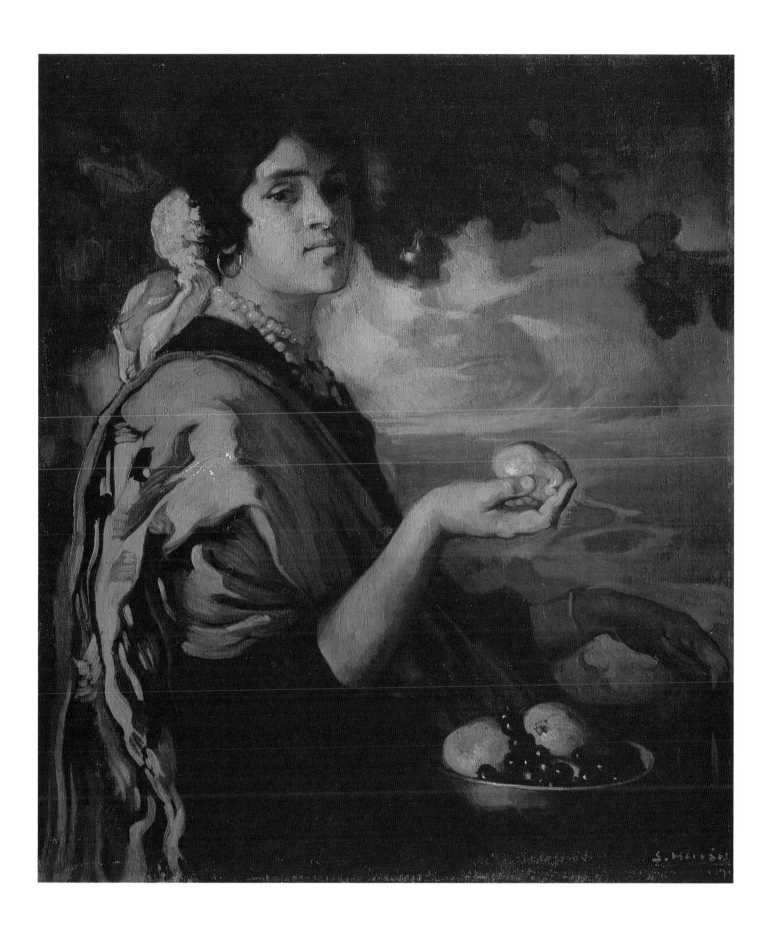

PLATE 1
**SATURNINO HERRÁN** (1887–1918)

*La criolla del mango*, 1916
Oil on canvas, 79.5 x 70 cm
Museo de la Ciudad de Aguascalientes, CONACULTA-INBA

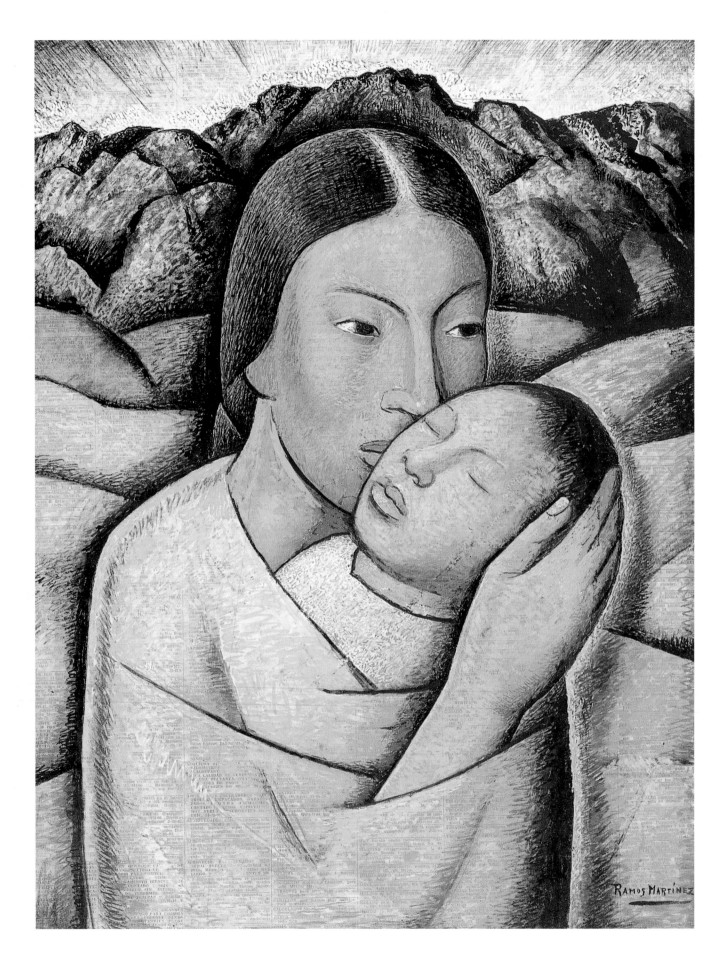

PLATE 2
**ALFREDO RAMOS MARTÍNEZ** (1871–1946)
*Maternidad,* 1924
Ink on revolution paper, 53 x 40 cm
Museo de Arte Moderno, CONACULTA-INBA

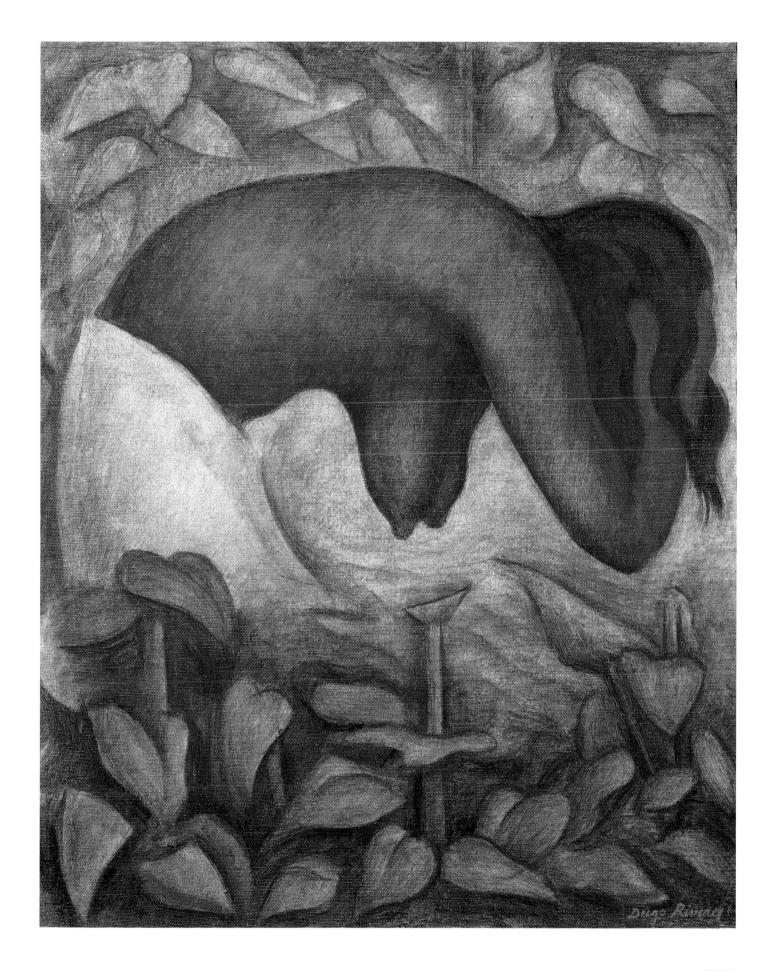

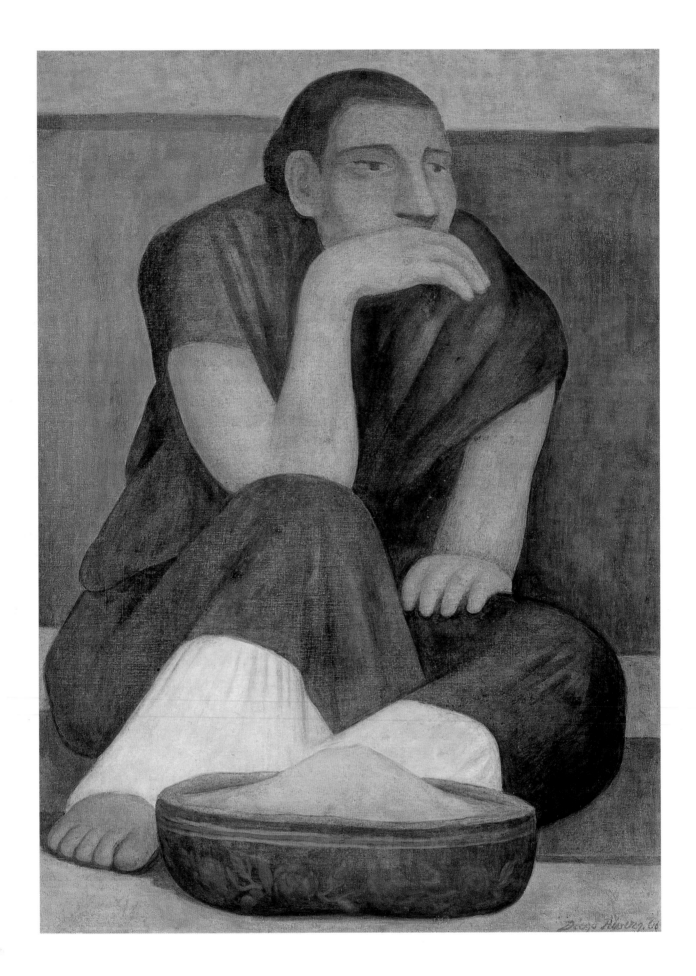

PLATE 4
**DIEGO RIVERA** (1886–1957)
*La vendedora de pinole*, 1936
Watercolor on canvas, 81.5 x 60.7 cm
Museo Nacional de Arte, CONACULTA-INBA

PLATE 5
**DIEGO RIVERA** (1886–1957)
*El modisto*, 1944
Oil on canvas, 121 x 152 cm
Collection Vicky y Marcos Micha

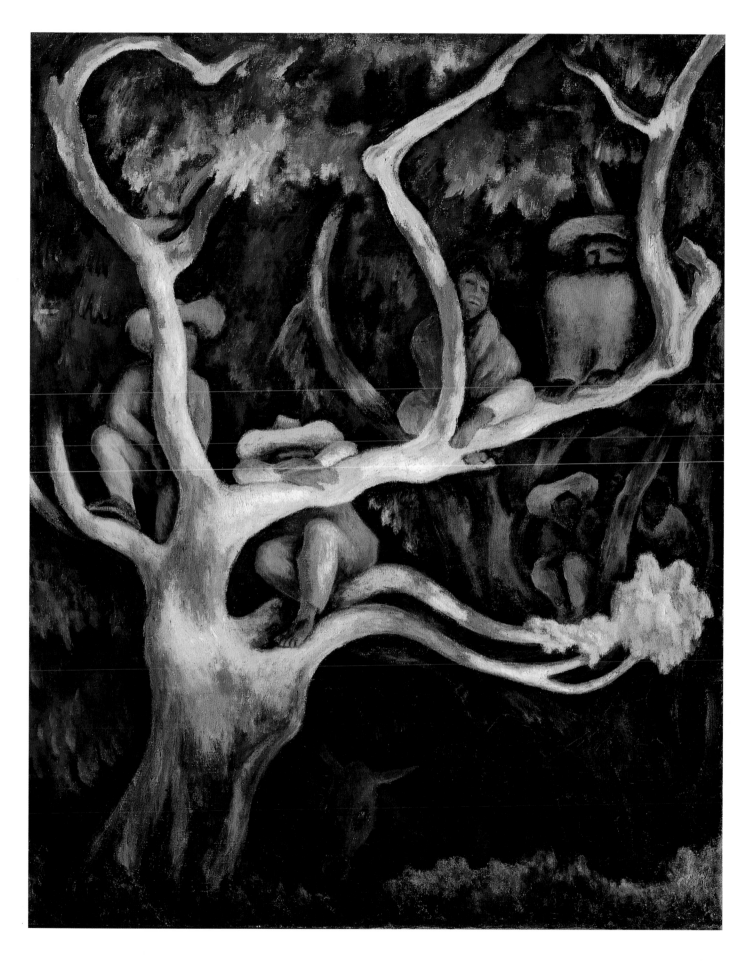

PLATE 6
**DIEGO RIVERA** (1886–1957)
*Paisaje nocturno*, 1947
Oil on canvas, 111 x 91 cm
Museo de Arte Moderno, CONACULTA-INBA

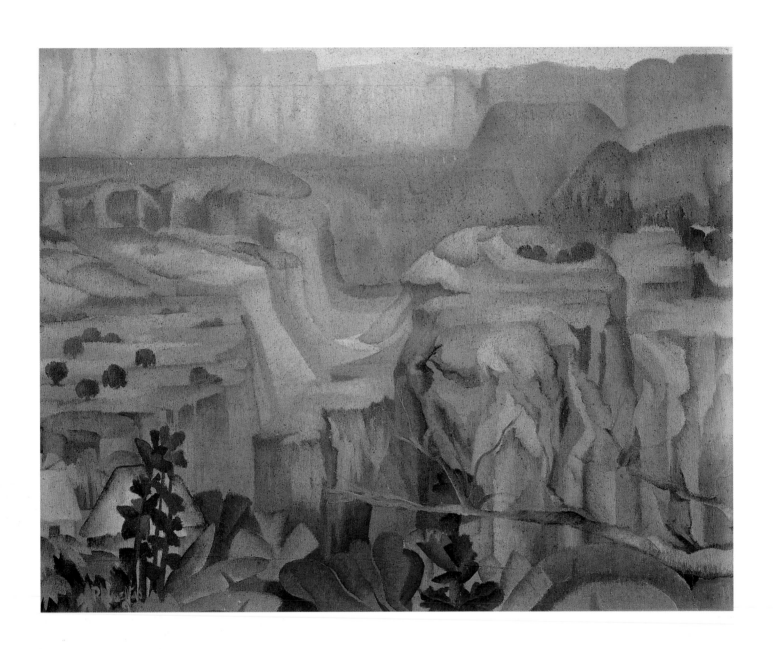

PLATE 7
**FERMÍN REVUELTAS** (1902–1935)
*La barranca de Oblatos,* 1933
Oil on canvas, 59 x 75 cm
Collection Ing. Silvestre Revueltas

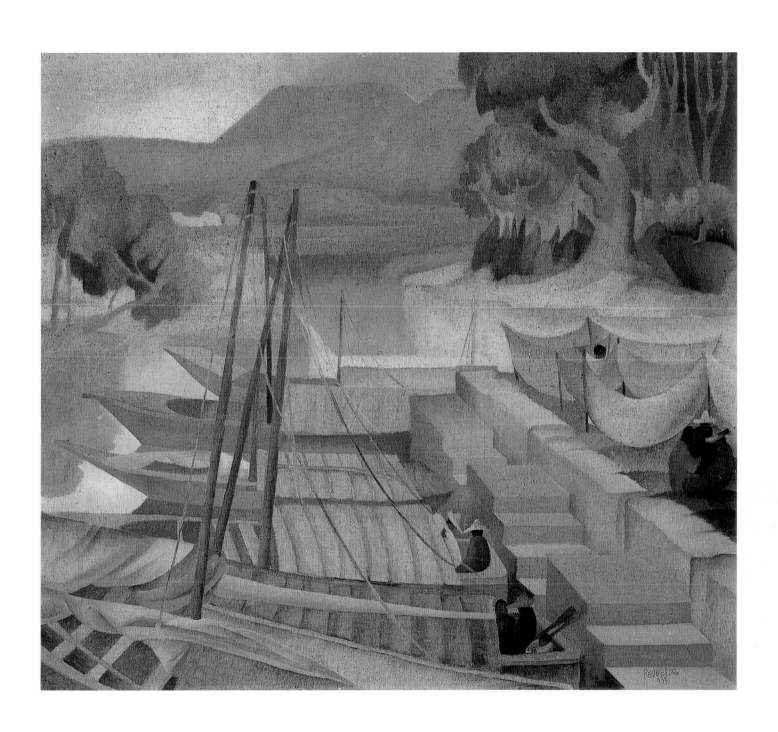

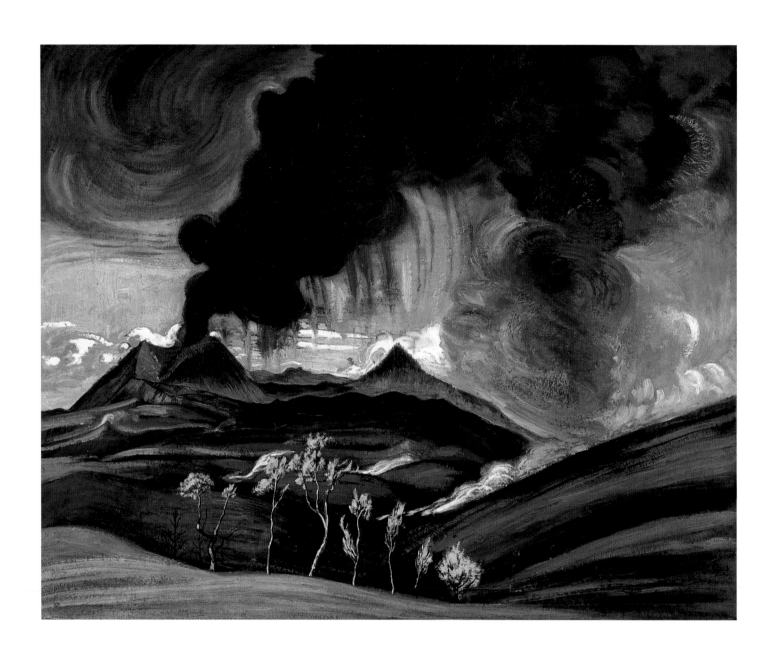

PLATE 9
GERARDO MURILLO (DR. ATL) (1875–1964)
*Nubes sobre el Paricutín*, nd
Atl colors on Celotex, 124 x 155 cm
CONACULTA-INBA

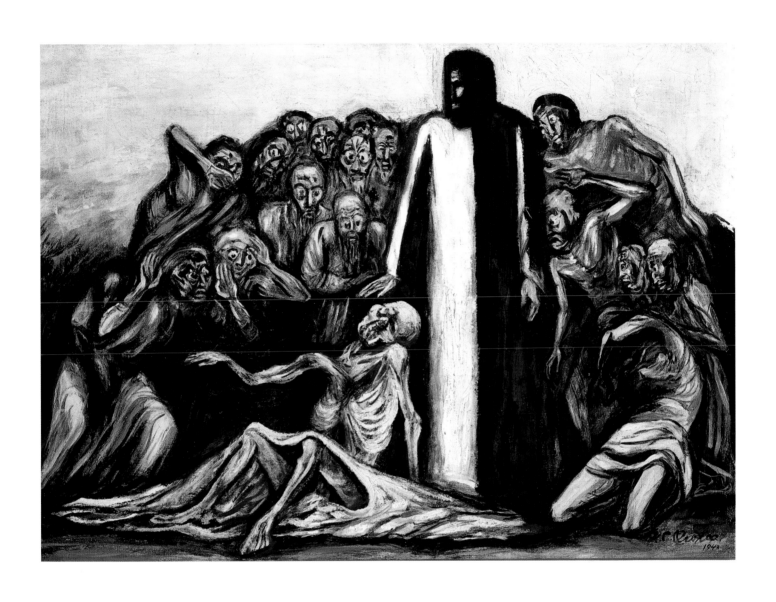

PLATE 10
JOSÉ CLEMENTE OROZCO (1883–1949)
*Resurrección de Lázaro*, 1943
Mixed media on canvas, 52 x 74 cm
Museo de Arte Moderno, CONACULTA-INBA

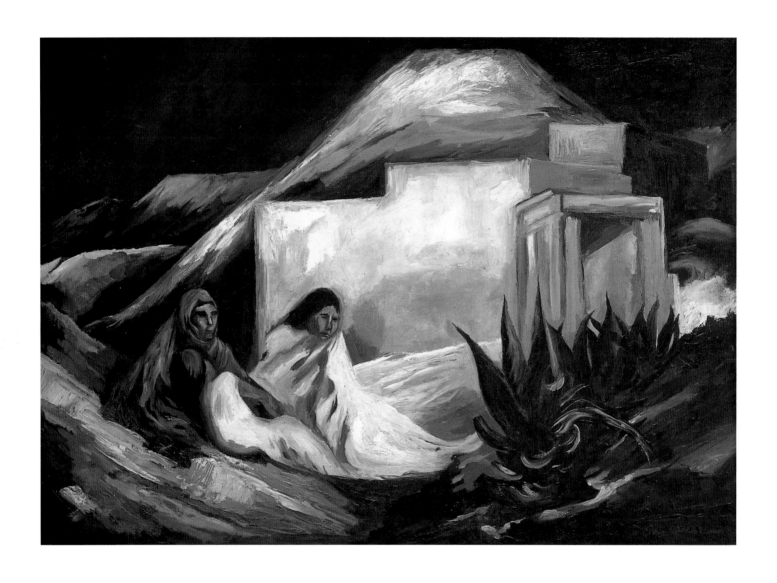

PLATE 11
**JOSÉ CLEMENTE OROZCO** (1883–1949)
*Colinas mexicanas*, 1930
Oil on canvas, 43 x 61 cm
Museo de Arte Álvar y Carmen T. de Carrillo Gil, CONACULTA-INBA

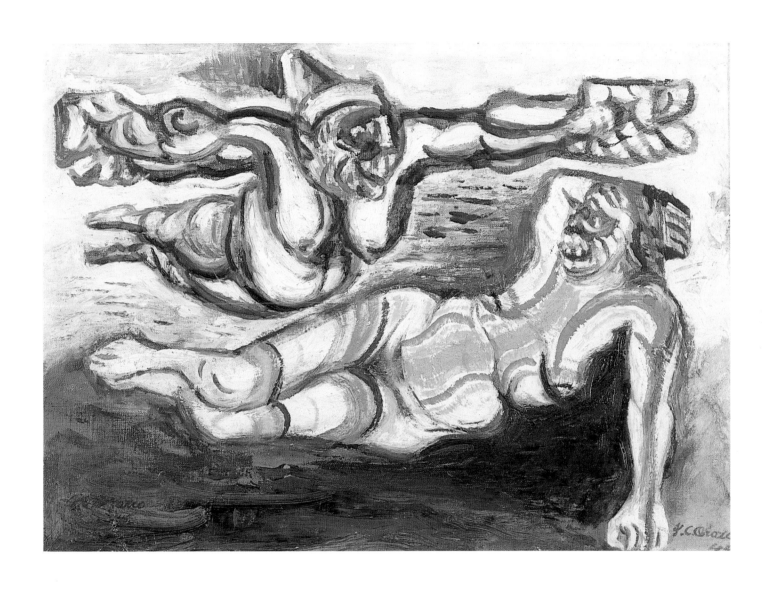

PLATE 12
JOSÉ CLEMENTE OROZCO (1883–1949)
*Mujer con figura volando*, 1945
Oil on canvas, 51.5 x 73 cm
Banco Nacional de México

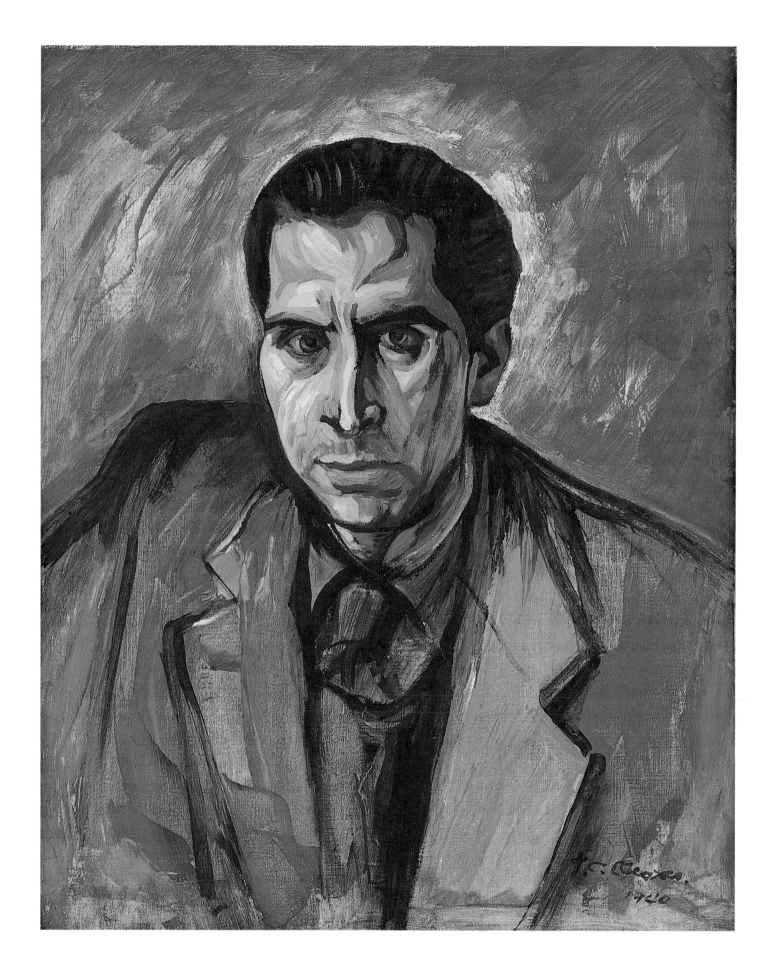

PLATE 13
**JOSÉ CLEMENTE OROZCO** (1883–1949)
*Retrato de Don Luis Cardoza y Aragón*, 1940
Tempera on canvas, 55 x 44 cm
Museo de Arte Moderno, CONACULTA-INBA

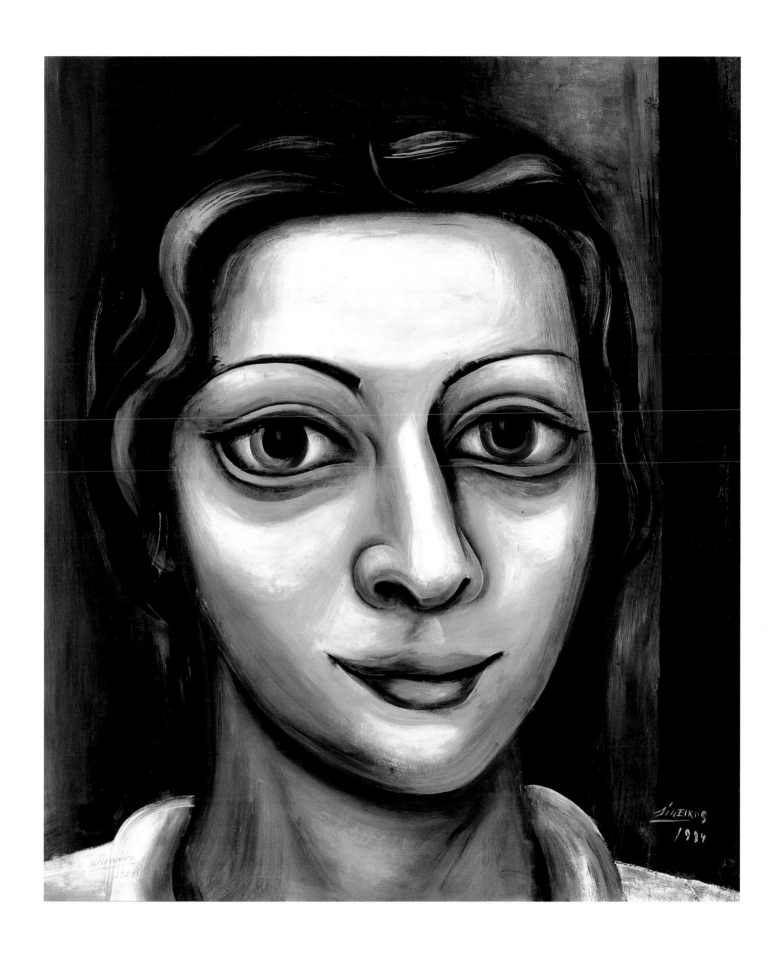

PLATE 15
JOSÉ DAVID ALFARO SIQUEIROS (1896–1974)
*Abstracción*, 1924
Pyroxylin on Bakelite, 81.5 x 92 cm
Museo de Arte Moderno, CONACULTA-INBA

PLATE 16
**GUILLERMO MEZA** (1917–1997)
*Los dioses en marcha*, 1949
Oil on canvas, 120 x 80 cm
Museo de Arte Moderno del Estado de México, Instituto Mexiquense de Cultura

PLATE 17
**JESÚS GUERRERO GALVÁN** (1910–1973)
*Nuestro pasado*, 1951
Oil on canvas, 49 x 51.5 cm
Collection Pascual Gutiérrez Roldán

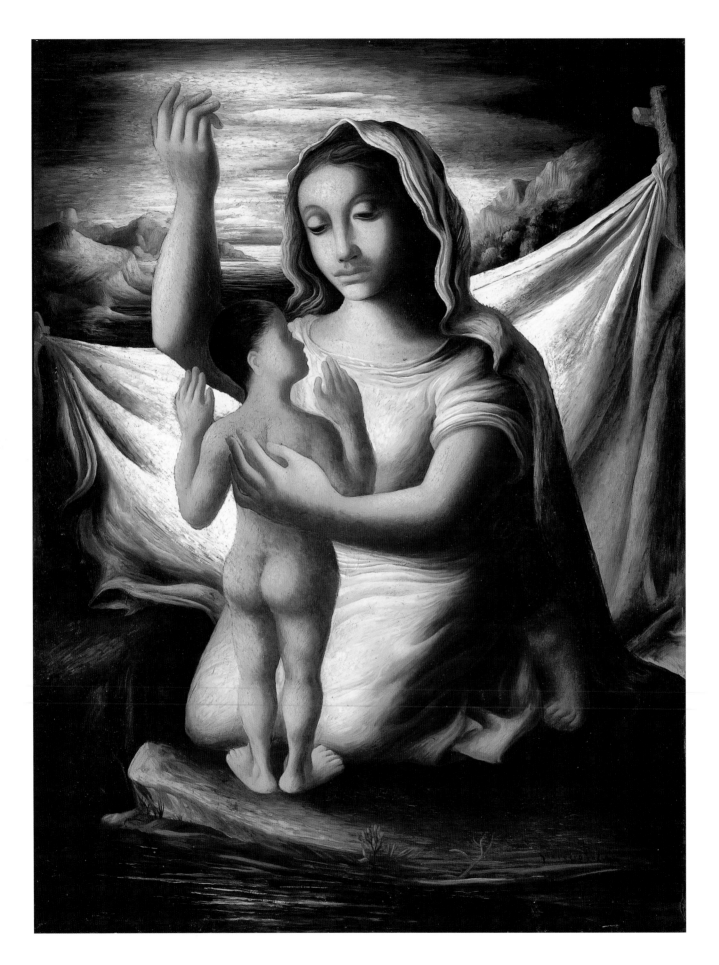

PLATE 18

**JESÚS GUERRERO GALVÁN** (1910–1973)

*Madonna con niño*, c. 1939

Oil on canvas, 80 x 61 cm

Private collection

PLATE 19
**JESÚS GUERRERO GALVÁN** (1910–1973)
*Niños con raqueta*, 1936
Oil on canvas, 88.9 x 63.5 cm
Private collection

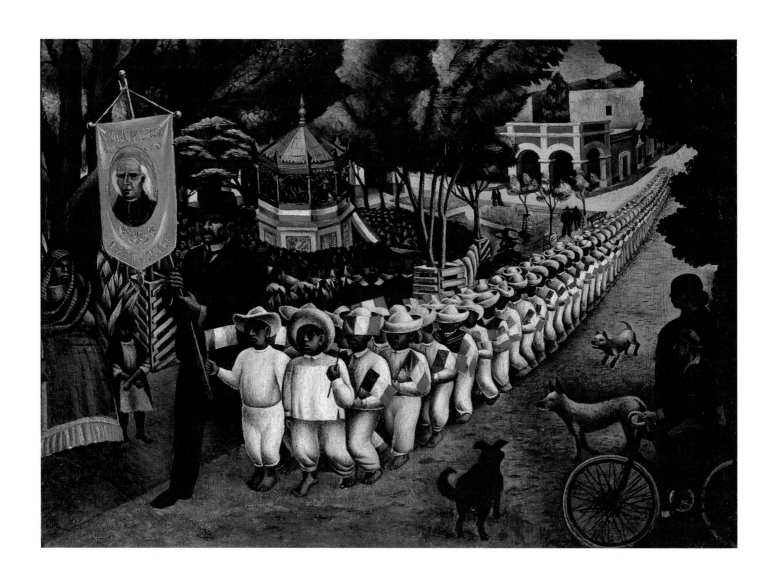

PLATE 20
**ANTONIO RUIZ (EL CORCITO)** (1897–1964)
*Desfile cívico escolar*, 1936
Oil on canvas, 46 x 56 cm
Secretaría de Hacienda y Crédito Público

PLATE 21
ANTONIO RUIZ (EL CORCITO) (1897–1964)
*Líder orador*, 1939
Oil on canvas, 31.2 x 22.3 cm
Private collection

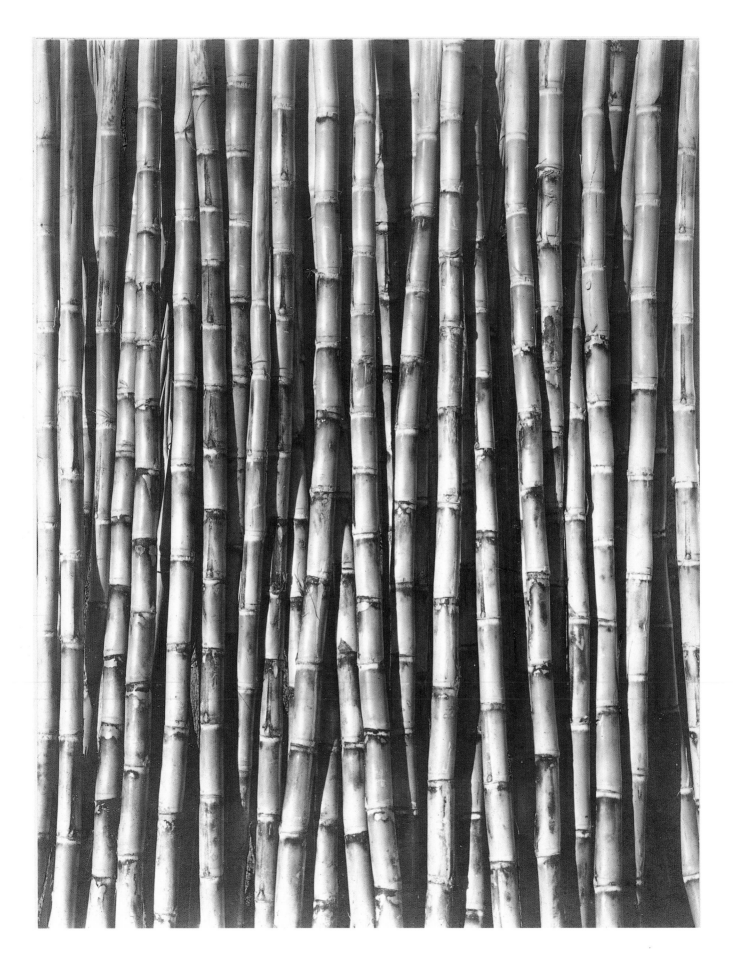

PLATE 22
**TINA MODOTTI** (1896–1942)
*Cañas de azúcar*, 1929
Silver gelatin print, 23.9 x 18.4 cm
Museo de Arte Moderno, CONACULTA-INBA

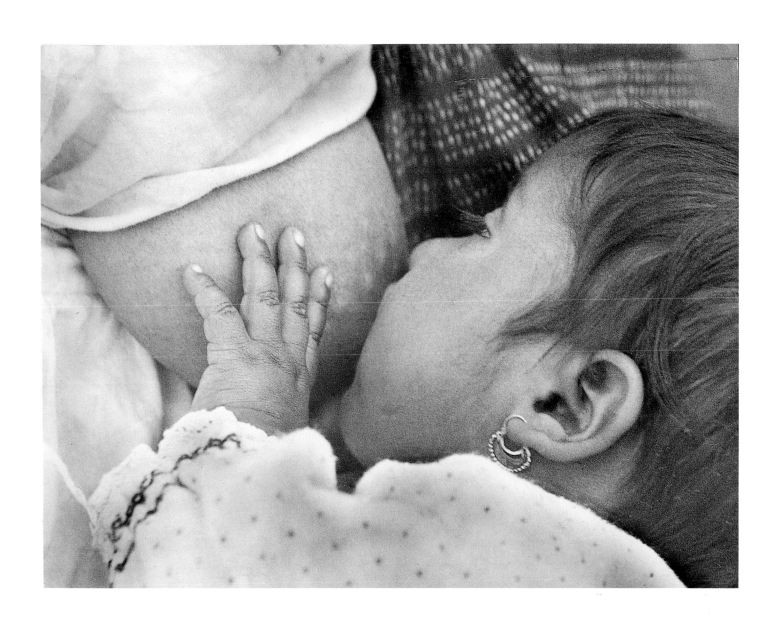

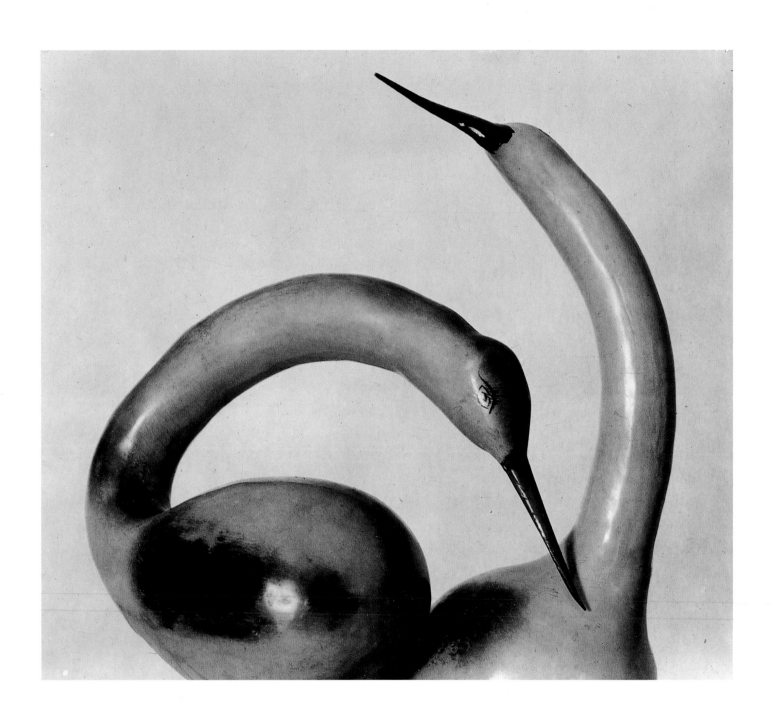

PLATE 24
**EDWARD WESTON** (1886–1958)
*Dos garzas de laca de Olinalá, México*, 1924
Silver gelatin print, 19 x 21.7 cm
Museo de Arte Moderno, CONACULTA-INBA

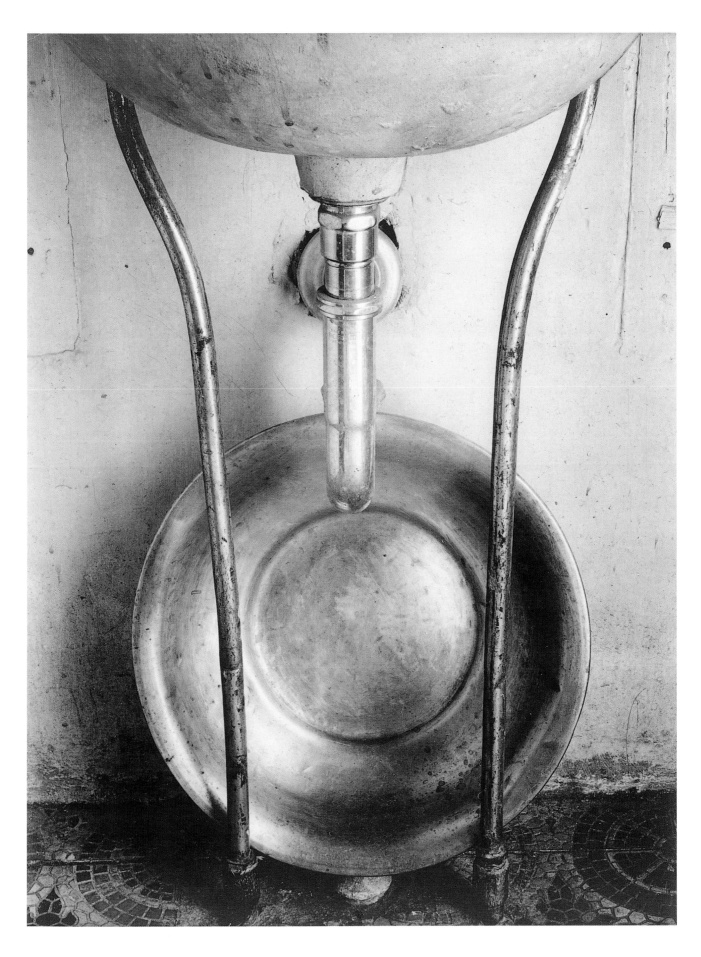

PLATE 25
**EDWARD WESTON** (1886–1958)
*Lavabo y aguamanil*, 1926
Silver gelatin print, 24 x 18.3 cm
Museo de Arte Moderno, CONACULTA-INBA

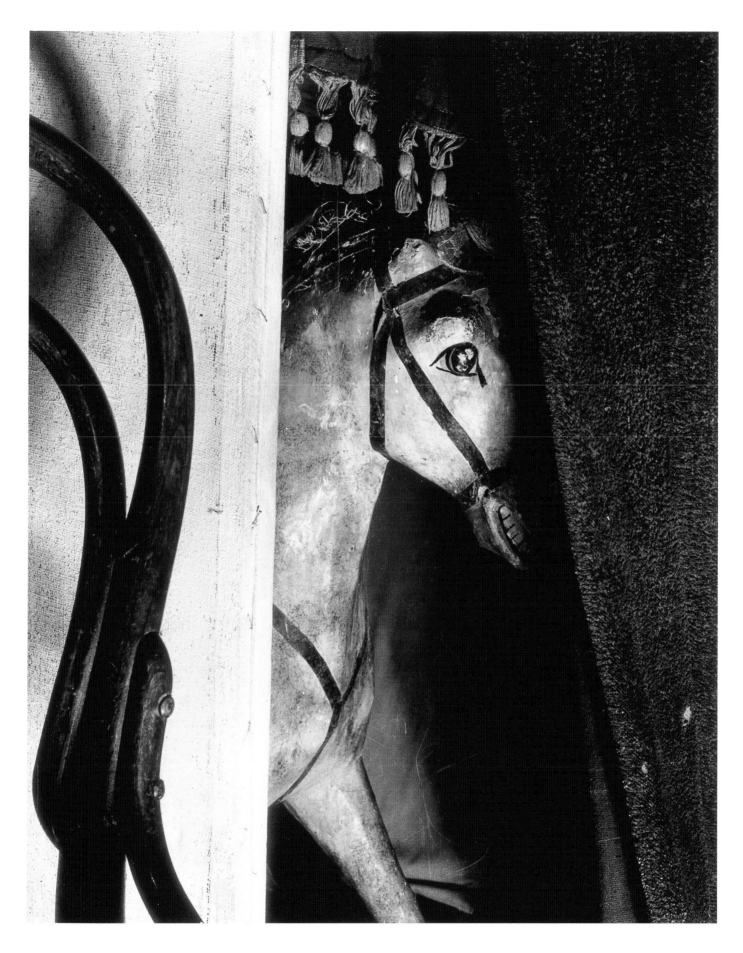

PLATE 26
**MANUEL ÁLVAREZ BRAVO** (1902–2002)
*Caballo de madera*, 1928
Silver gelatin print, 23.8 x 19 cm
Museo de Arte Moderno, CONACULTA-INBA

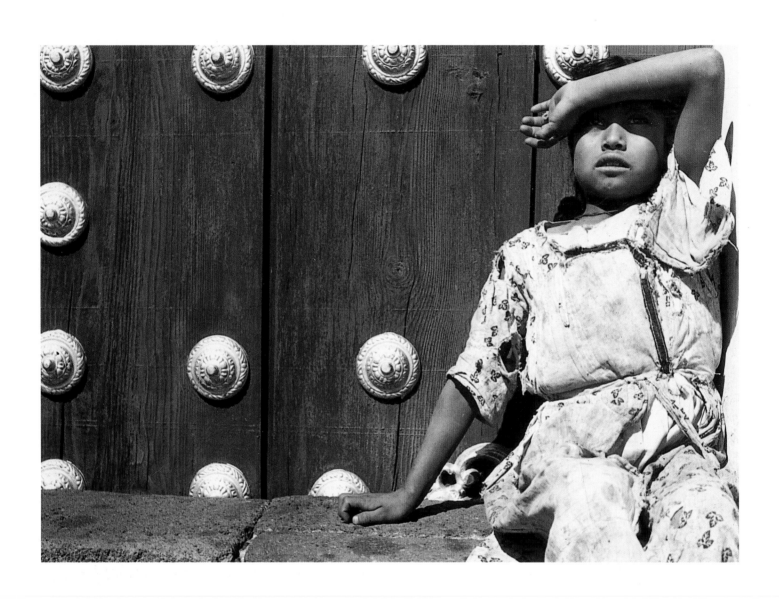

PLATE 27
**MANUEL ÁLVAREZ BRAVO** (1902–2002)
*Muchacha viendo pájaros (Cholula Puebla)*, 1931
Silver gelatin print, 17.5 x 24.2 cm
Museo de Arte Moderno, CONACULTA-INBA

PLATE 28
**MANUEL ÁLVAREZ BRAVO** (1902–2002)
*Los agachados*, 1934
Silver gelatin print, 18.3 x 24.1 cm
Museo de Arte Moderno, CONACULTA-INBA

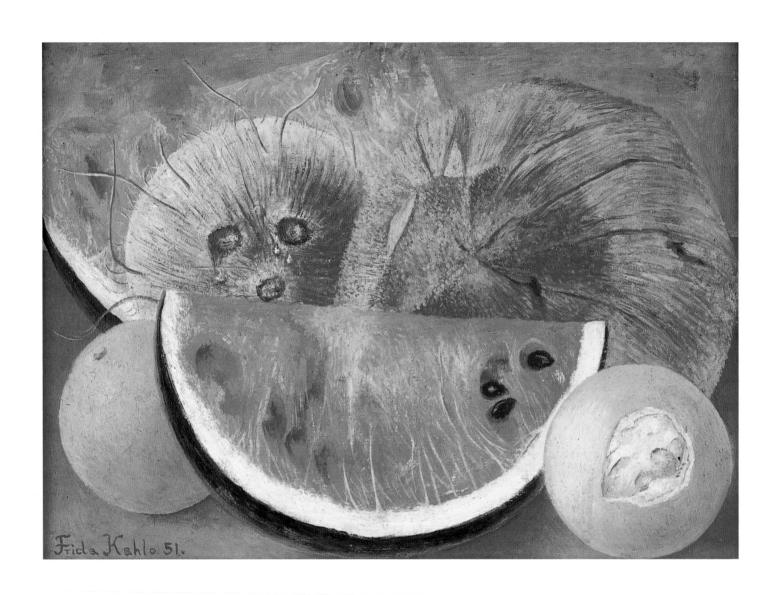

PLATE 29
**FRIDA KAHLO** (1907–1954)
*Los cocos*, 1951
Oil on canvas, 25.5 x 35.3 cm
Museo de Arte Moderno, CONACULTA-INBA

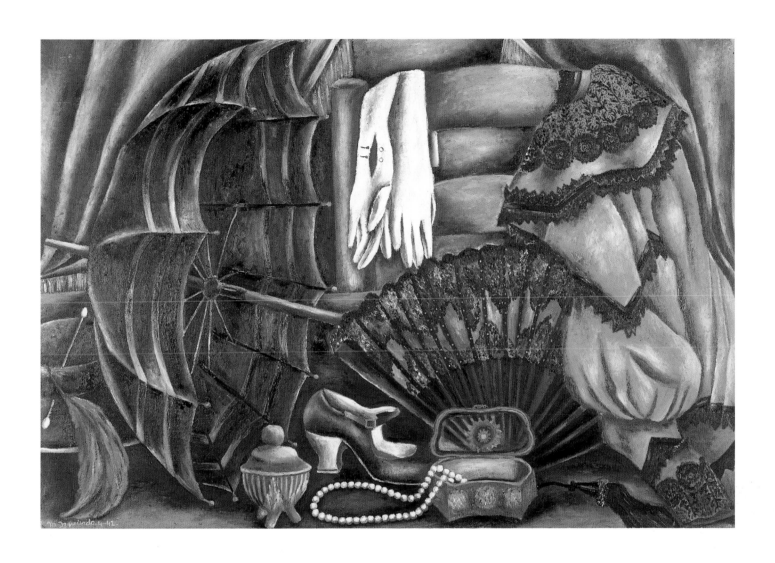

PLATE 31
**MARÍA IZQUIERDO** (1906–1955)
*Mujer Oaxaqueña*, 1940
Oil on Masonite, 61 x 50 cm
Collection Pascual Gutiérrez Roldán

PLATE 32
**MARÍA IZQUIERDO** (1906–1955)
*Niñas durmiendo*, 1932
Oil on canvas, 52.5 x 71 cm
Museo de Arte Moderno, CONACULTA-INBA

PLATE 33
**MARÍA IZQUIERDO** (1906–1955)
*Viernes de juguetería*, 1952
Oil on canvas, 76 x 66 cm
Museo Nacional de Arte, CONACULTA-INBA

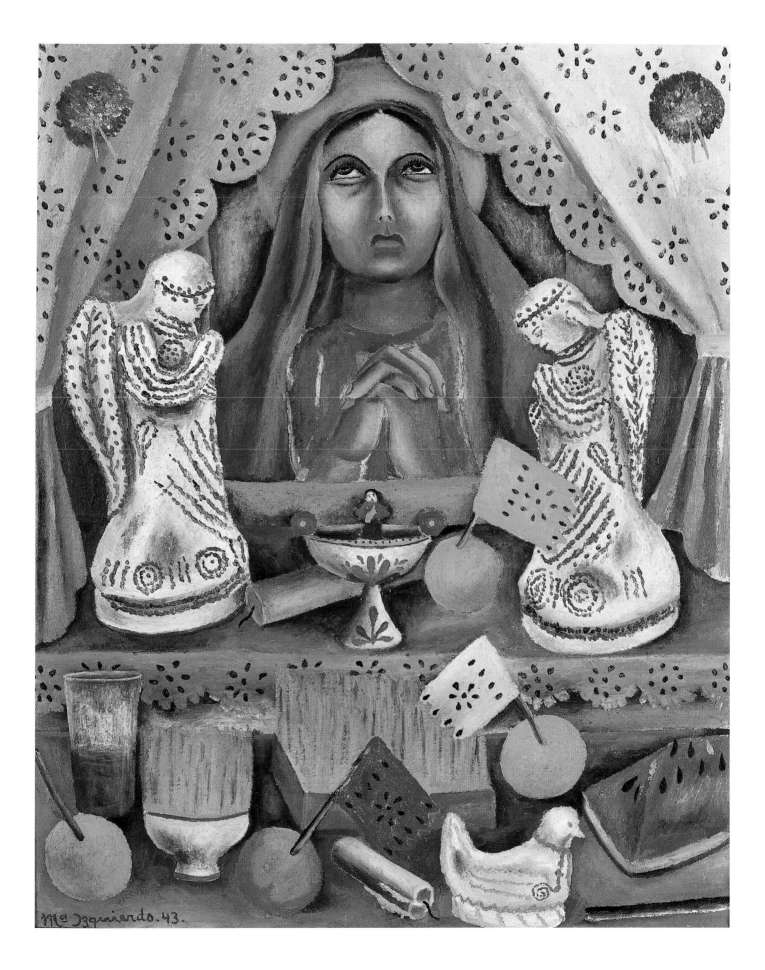

PLATE 34
MARÍA IZQUIERDO (1906–1955)
*Altar de Dolores*, 1943
Oil on canvas, 63.5 x 53.3 cm
Private collection

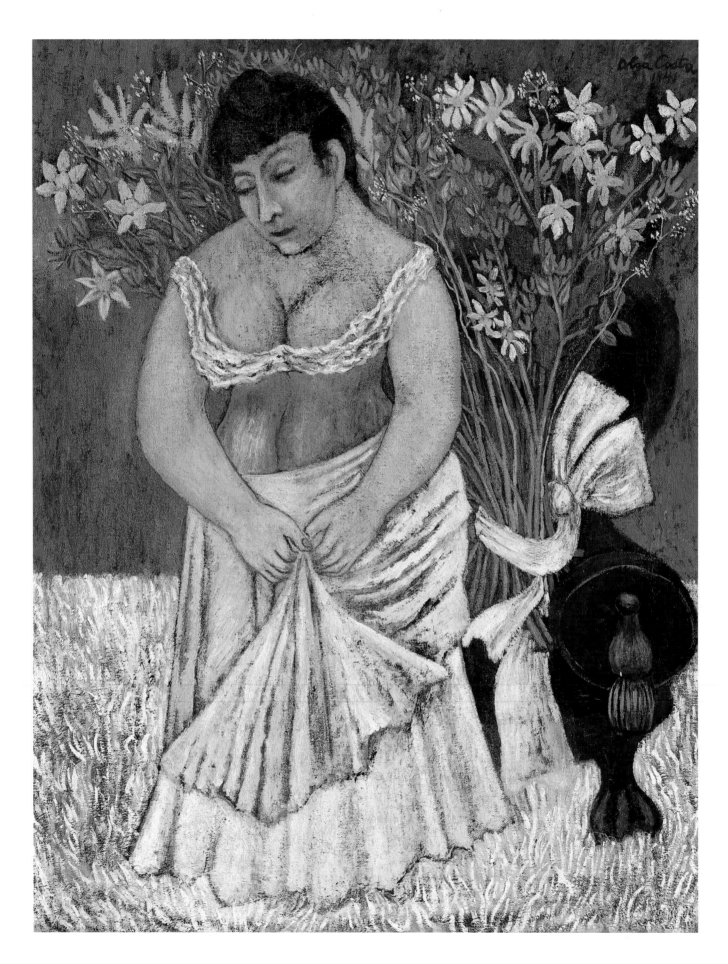

PLATE 35
**OLGA COSTA** (1913–1993)
*La novia*, 1941
Oil on canvas, 70 x 55 cm
Museo de Arte Olga Costa–José Chávez Morado, Guanajuato.

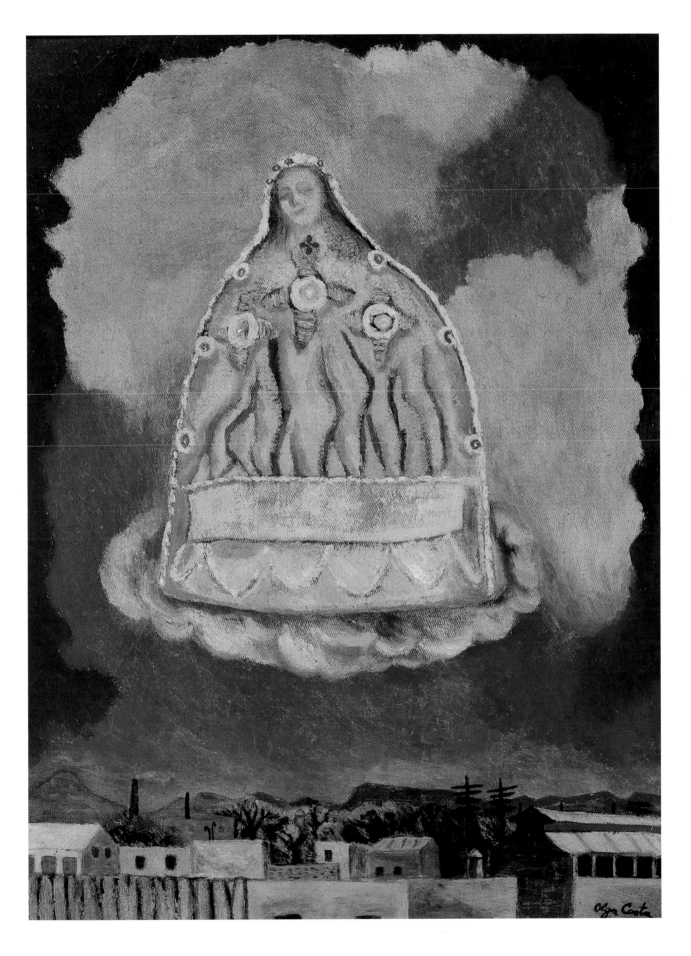

PLATE 36
**OLGA COSTA** (1913–1993)
*Retablo*, 1942
Oil on canvas, 39 x 28.5 cm
Collection Ing. Eduardo Morillo Safa

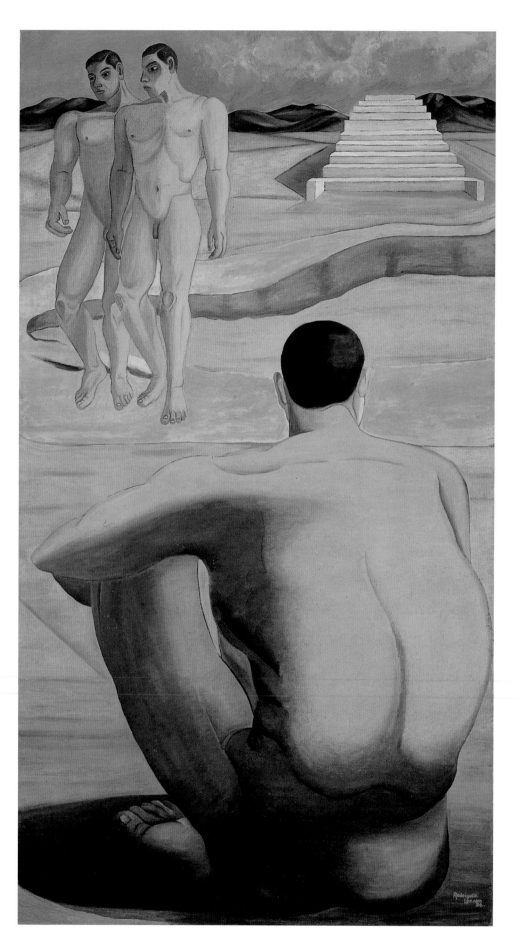

PLATE 37

**MANUEL RODRÍGUEZ LOZANO** (1897–1971)

*El pensador*, 1935

Oil on canvas, 200 x 110 cm

Collection Eugenia Rendón de Olazábal

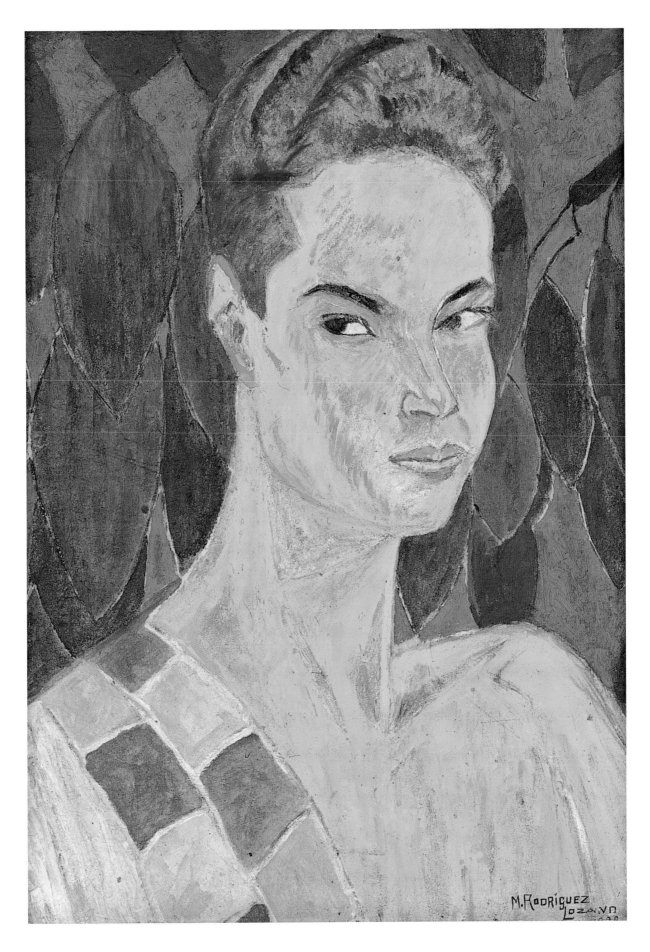

PLATE 38
**MANUEL RODRÍGUEZ LOZANO** (1897–1971)
*Retrato de Abraham Ángel*, 1924
Oil on cardboard, 59 x 41 cm
Museo de Arte Moderno, CONACULTA-INBA

PLATE 39
**MANUEL RODRÍGUEZ LOZANO** (1897–1971)
*Santa Ana muerta con dos figuras*, 1932
Oil on canvas, 37 x 48.7 cm
Museo de Arte Moderno, CONACULTA-INBA

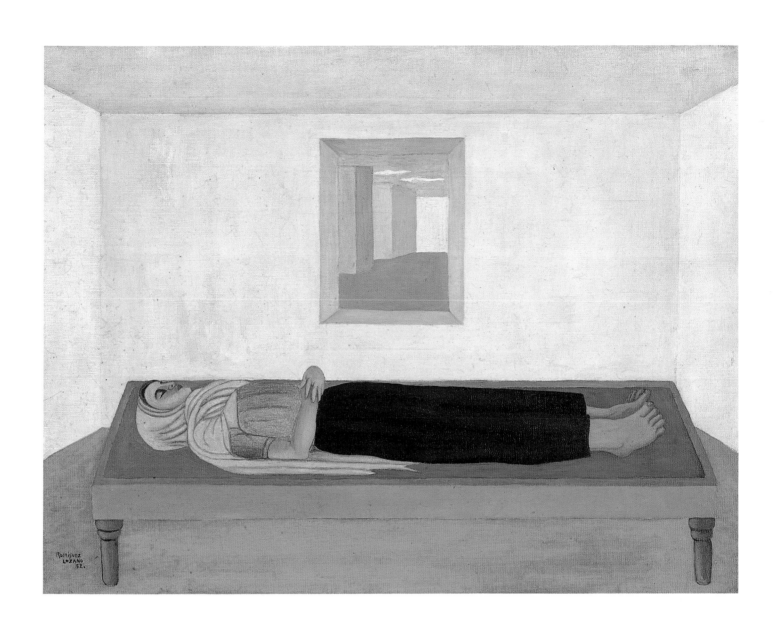

PLATE 40
**MANUEL RODRÍGUEZ LOZANO** (1897–1971)
*Santa Ana muerta*, 1932
Oil on canvas, 37 x 48.5 cm
Museo de Arte Moderno, CONACULTA-INBA

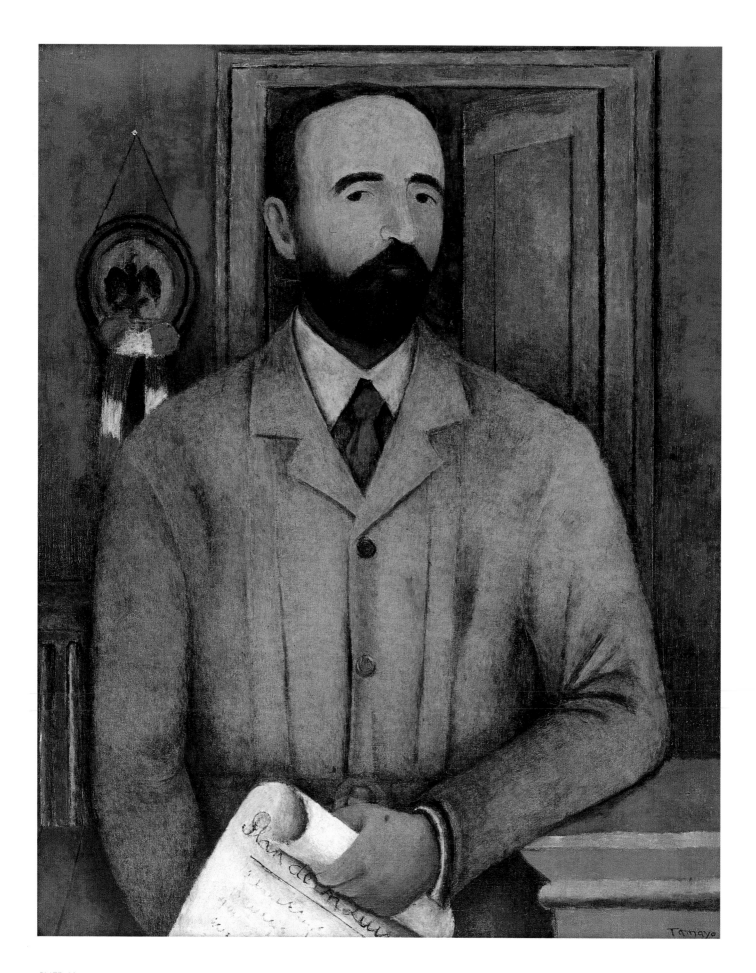

PLATE 41
**RUFINO TAMAYO** (1899–1991)
*Francisco I. Madero*, 1948
Oil on canvas, 95 x 75 cm
Museo de Arte Moderno, CONACULTA-INBA

PLATE 42
**RUFINO TAMAYO** (1899–1991)
*Homenaje a Juárez*, 1932
Oil on canvas, 60 x 74 cm
Museo de Arte Moderno, CONACULTA-INBA

PLATE 43
**RUFINO TAMAYO** (1899–1991)
*El borracho feliz*, 1946
Oil on canvas, 101.6 x 86.3 cm
Private collection

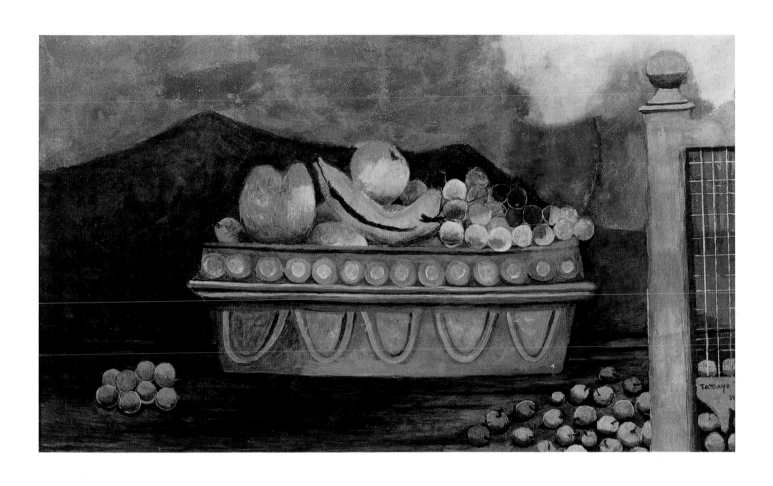

PLATE 44
**RUFINO TAMAYO** (1899–1991)
*Frutero azul (Frutero con frutas)*, 1939
Oil on canvas, 34 x 59.9 cm
Museo de Arte Moderno, CONACULTA-INBA

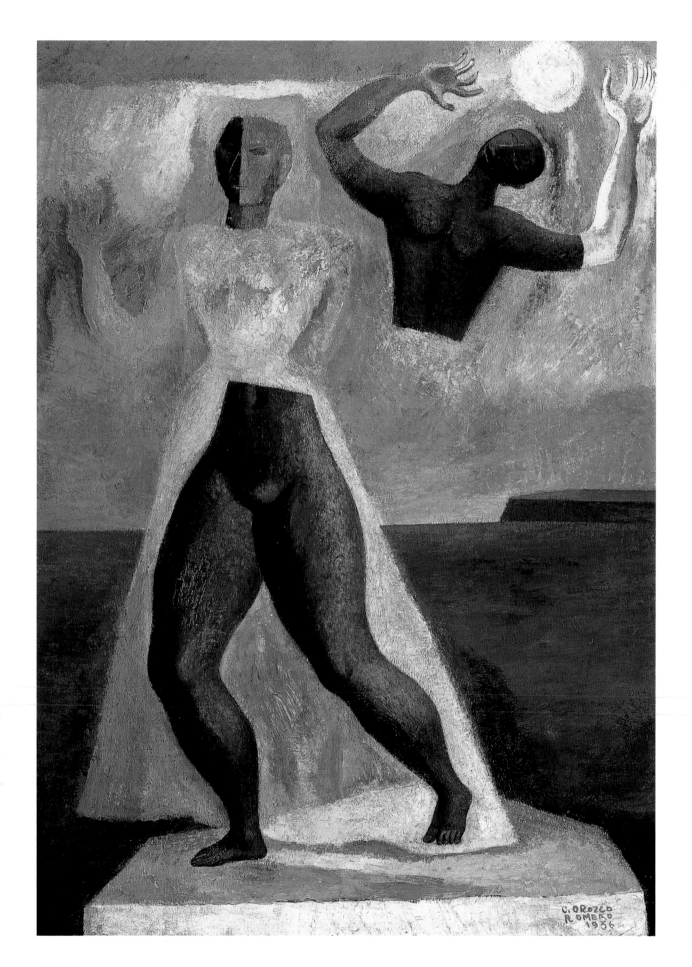

PLATE 45
**CARLOS OROZCO ROMERO** (1898–1984)
*Deseo, 1936*
Oil on canvas, 54 x 74 cm
Collection Gene Cady Gerzso / Michael Gerzso

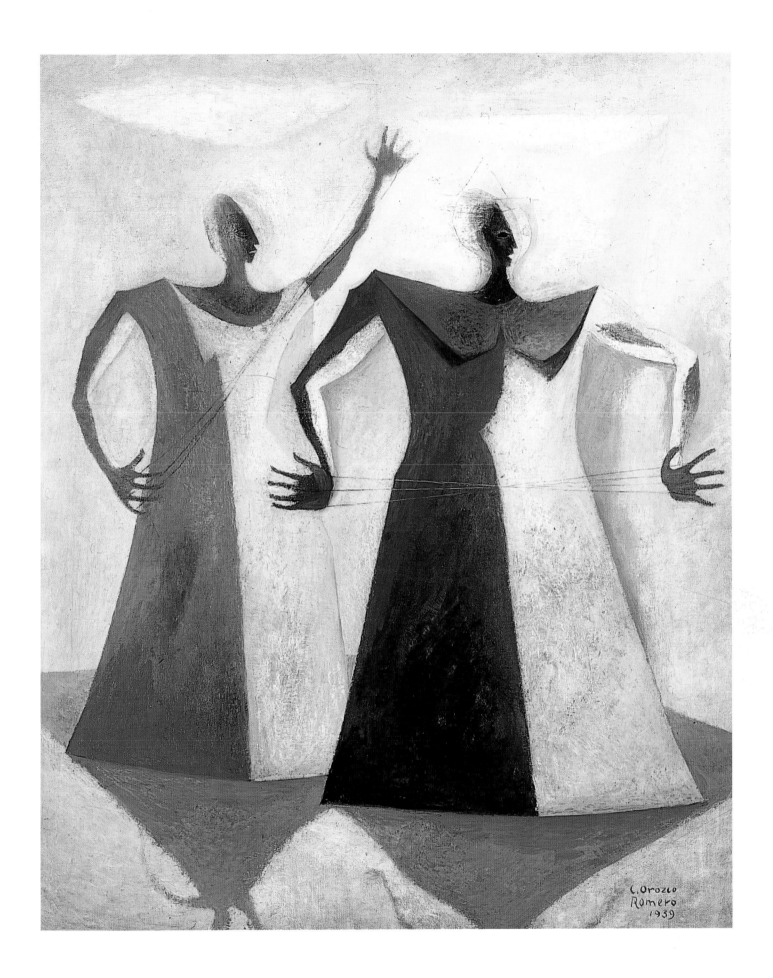

PLATE 46
CARLOS OROZCO ROMERO (1898–1984)
*Los hilos*, 1939
Oil on canvas, 68 x 56 cm
Museo de Arte Moderno, CONACULTA-INBA

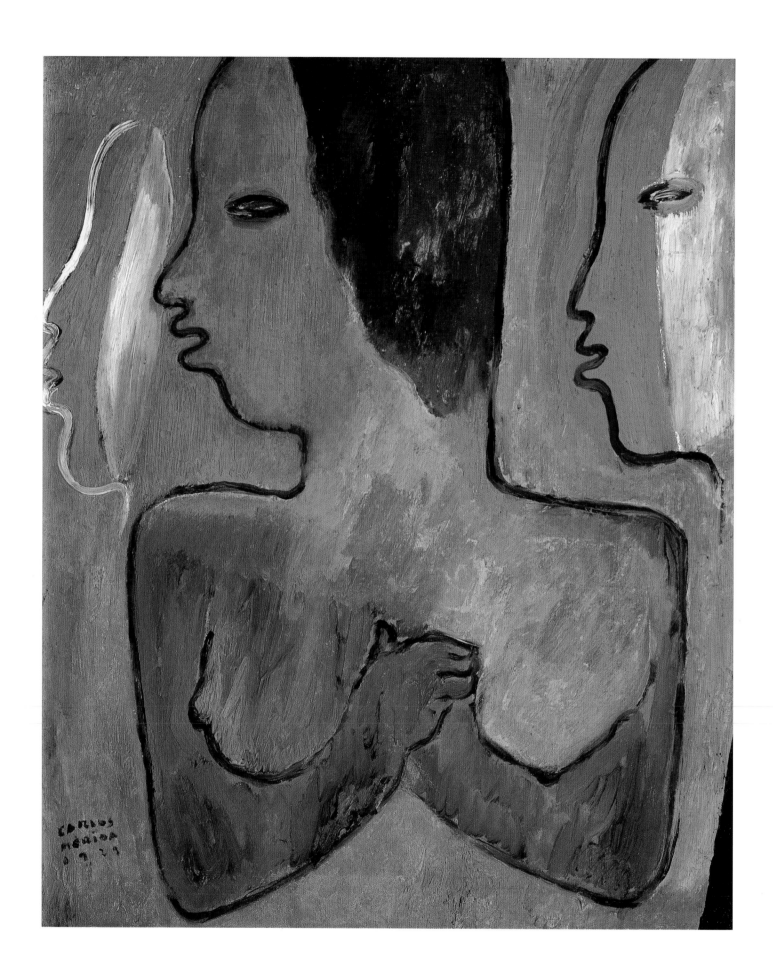

PLATE 47
CARLOS MÉRIDA (1891–1984)
*Perfiles*, 1929
Oil on canvas, 73.5 x 63.5 cm
Museo de Arte Moderno del Estado de México, Instituto Mexiquense de Cultura

PLATE 48
GABRIEL FERNÁNDEZ LEDESMA (1900–1983)
*Interior sin personajes*, 1935
Oil on wood panel, 47 x 54 cm
Private collection

PLATE 49
**GABRIEL FERNÁNDEZ LEDESMA** (1900–1983)
*Mujer peinándose*, 1938
Oil on canvas, 90 x 75 cm
Collection Lic. Agustín Alanis Fuentes

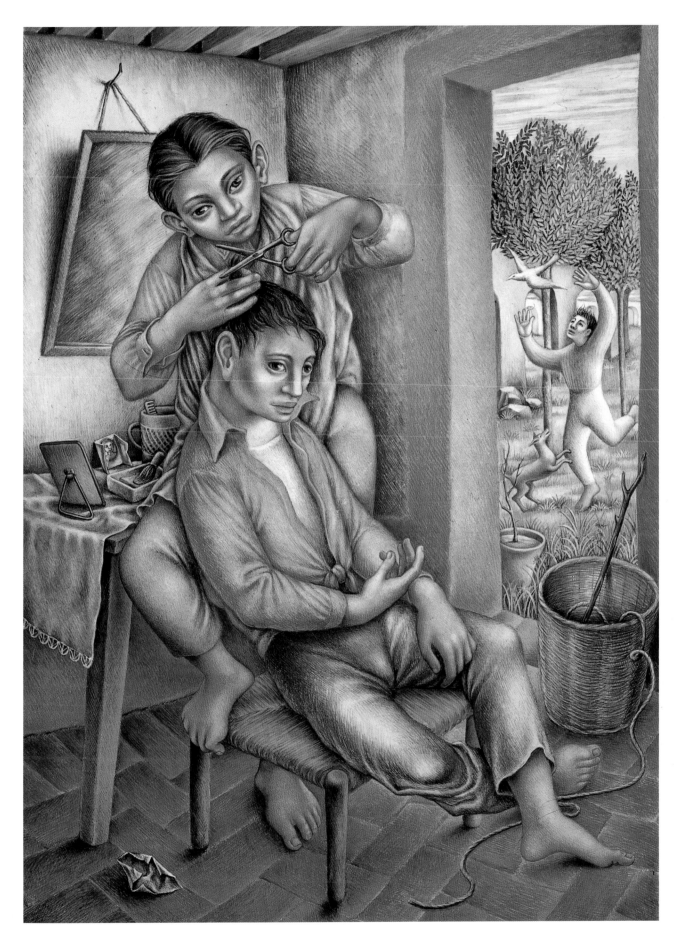

PLATE 50
**EMILIO BAZ VIAUD** (1918–1991)
*El peluquero zurdo*, 1949
Tempera on cardboard, 85 x 73 cm
Banco Nacional de México

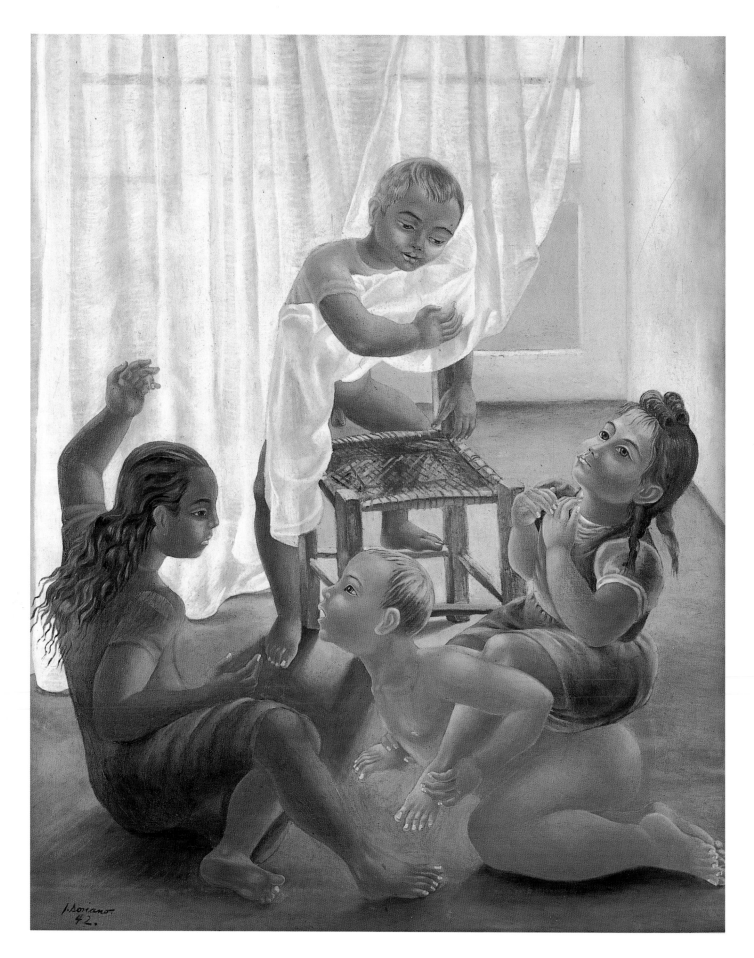

PLATE 51
**JUAN SORIANO** (1920–2006)
*Juego de niños*, 1942
Oil on canvas, 110 x 90 cm
Museo de Arte Moderno, CONACULTA-INBA

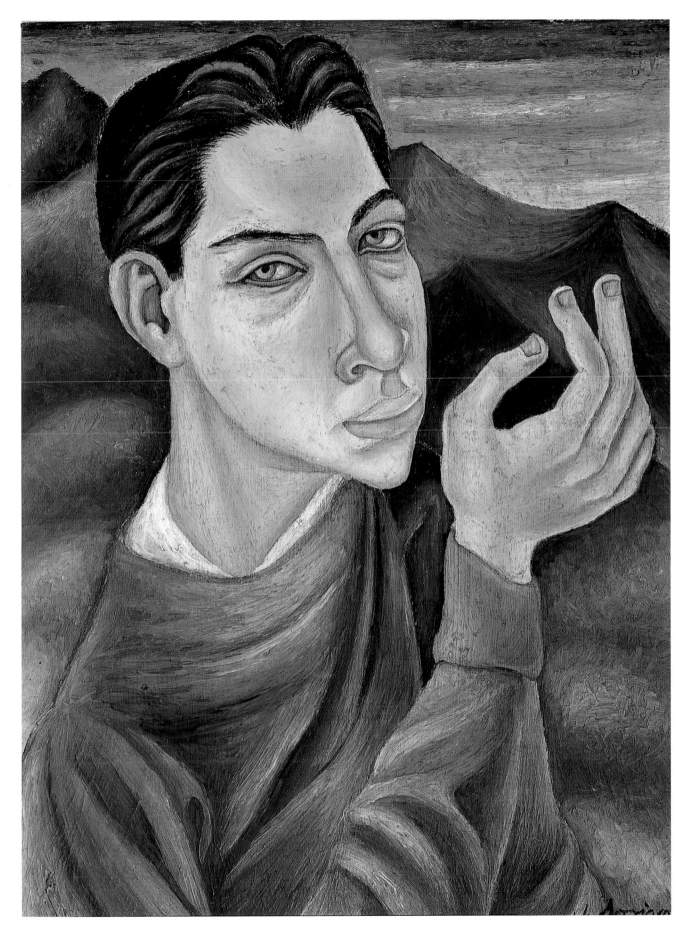

PLATE 52
**JUAN SORIANO** (1920–2006)
*Autorretrato*, 1937
Oil on wood panel, 38.5 x 30 cm
Collection Eugenia Rendón de Olazábal

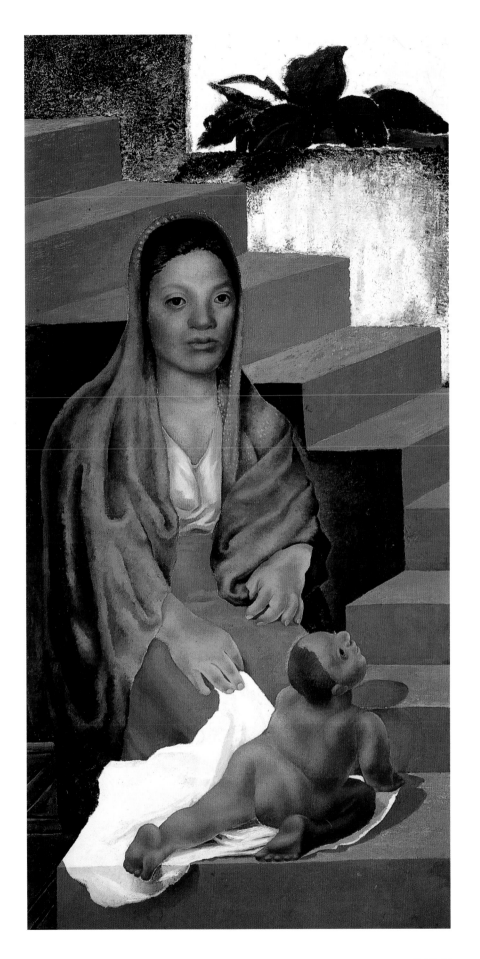

PLATE 53
JULIO CASTELLANOS (1905–1947)
*Madonna*, 1932
Oil on canvas, 133 x 67 cm
Collection Lance Aaron and family

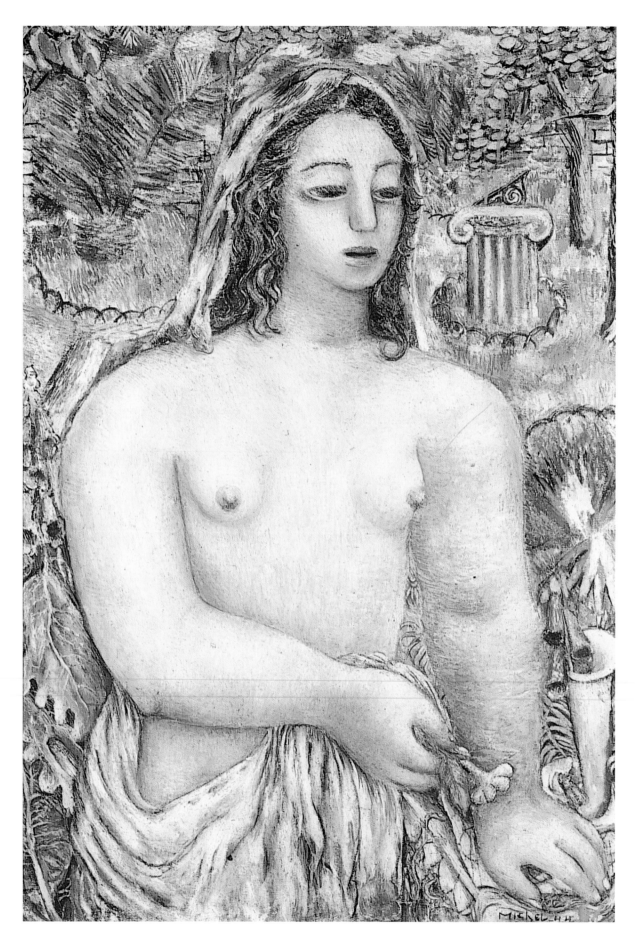

PLATE 54

**ALFONSO MICHEL** (1897–1957)
*Mujer con manto blanco*, 1944
Oil on canvas, 102 x 75 cm
Banco Nacional de México

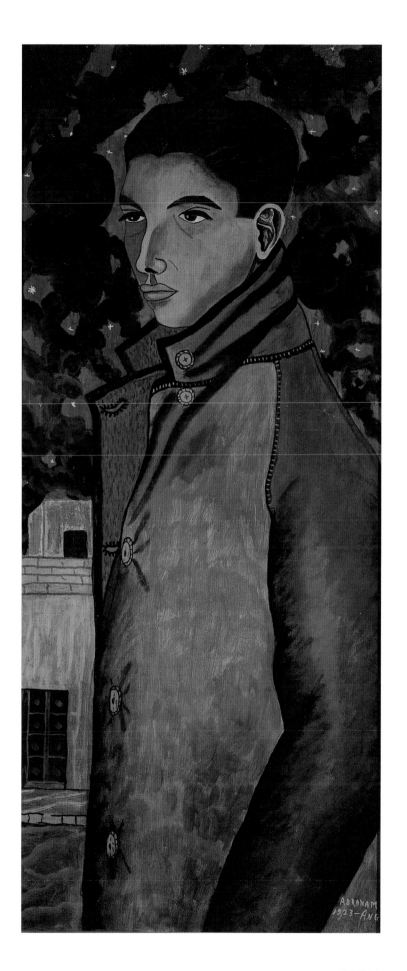

PLATE 55
**ABRAHAM ÁNGEL** (1905–1924)
*Cadete*, 1923
Oil on cardboard, 120 x 52 cm
Museo de Arte Moderno, CONACULTA-INBA

PLATE 56
**ABRAHAM ÁNGEL** (1905–1924)
*Lupe y María*, 1923
Oil on cardboard, 112.5 x 121.5 cm
Museo de Arte Moderno, CONACULTA-INBA

*Mexican Modern: Masters of the 20th Century* accompanies an exhibition at the Museum of Fine Arts, Santa Fe, May 28–September 3, 2006.

Director: Anna Gallegos
Project editor: Mary Wachs
Art director: David Skolkin
Photography: Francisco Kochen
Designed and typeset by David Skolkin
Set in Aldus and Futura
Manufactured by Arizona Lithographers, Tucson, Arizona
10 9 8 7 6 5 4 3 2 1

ISBN 978-0-89013-490-0

Museum of New Mexico Press
Post Office Box 2087
Santa Fe, New Mexico 87504

Page 1, Manuel Rodríguez Lozano (see plate 38); page 2, Rufino Tamayo (see plate 43); page 14, Carlos Orozco Romero (see plate 46); page 24, María Izquierdo (see plate 33).